THE
Old Photographs
SERIES

THE MIDLAND & SOUTH WESTERN

JUNCTION RAILWAY

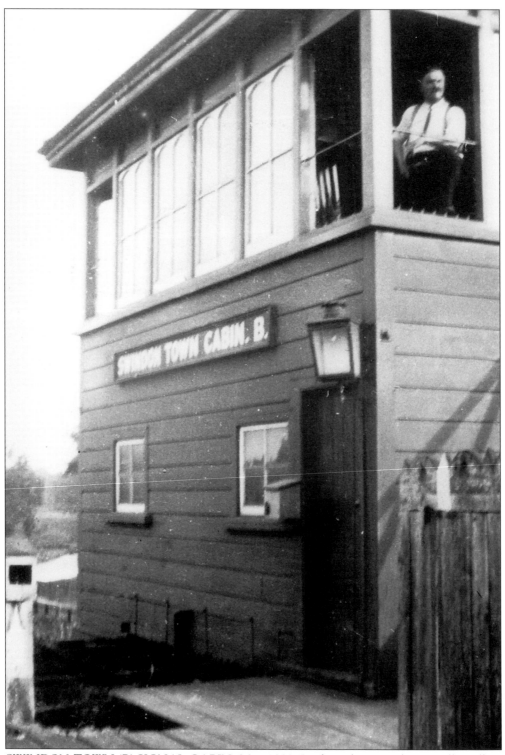

SWINDON TOWN 'B' SIGNAL CABIN, May 1929. Looking from window is Bill Walker, signalman.

THE
Old Photographs
SERIES

THE MIDLAND & SOUTH WESTERN
JUNCTION RAILWAY

Compiled by
Brian Bridgeman and Mike Barnsley

CHALFORD

BATH • AUGUSTA • RENNES

The Chalford Publishing Company Limited
St Mary's Mill, Chalford, Stroud
Gloucestershire GL6 8NX

ISBN 07524 0016 9

Typesetting and origination by
Alan Sutton Limited
Printed in Great Britain by
Redwood Books, Trowbridge

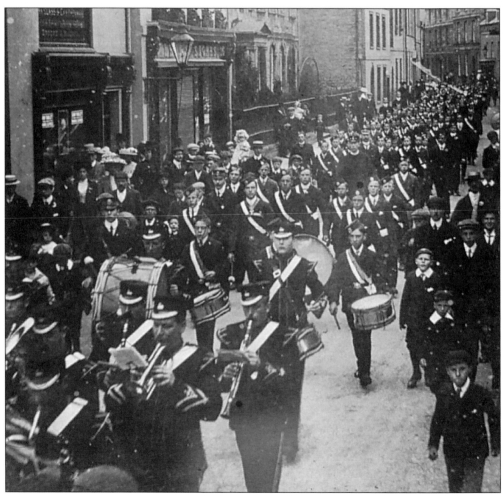

MSWJR WORKS BAND, parading through Cirencester, c.1910. See p. 42.

Contents

Introduction 7

1. The Cheltenham Connection 9

2. Over the Cotswolds 21

3. Cirencester 35

4. Into North Wiltshire 51

5. Swindon 67

6. Over the Downs 83

7. Marlborough and South Wiltshire 99

8. The Army 117

9. Into Hampshire 131

10. Locos and Trains 143

Acknowledgements 160

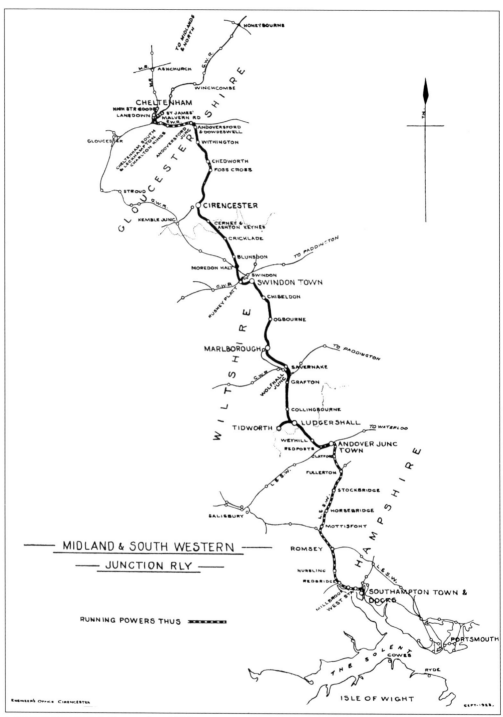

MSWJR SYSTEM, September 1923.

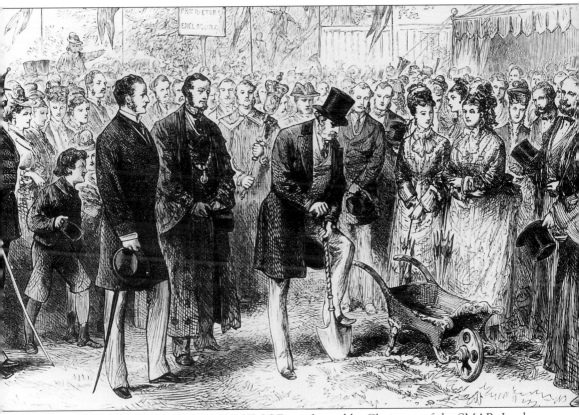

CEREMONY OF CUTTING THE FIRST SOD, performed by Chairman of the SMAR, Lord Ernest Bruce, at Cold Harbour meadow, Marlborough, 28 July 1875. The rejoicings were somewhat spoiled when the wheel of the ceremonial barrow broke down – a bad omen for the future of the line...

Introduction

In the mid-nineteenth century, the railways in the countryside between London and Bristol were controlled by the Great Western Railway. They differed from the railways of the Midlands and the South in that they were to Brunel's 7-foot gauge, instead of the standard gauge of 4ft 8½ins. At the heart of this broad gauge empire were the GWR headquarters at New Swindon.

The GWR fought hard to protect its monopoly position, opposing various schemes to invade its territory. But eventually a small company had the temerity to set up its own headquarters at Swindon, right in the GWR heartland, and to drive a standard gauge line north–south through the town that the GWR liked to think of as its own.

The interloper started life as the Swindon, Marlborough & Andover Railway. At first it tried to tunnel under Swindon Hill to meet up with the GWR at Swindon Junction station, but had to admit defeat. It then built its own station off Newport Street in Old Town, and took its line on around the west side of the town to connect with the GWR main line at Rushey Platt. The line from Swindon to Marlborough opened in 1881, and the southern section from Grafton to Andover opened in 1882, but problems at Savernake prevented through running between Swindon and Andover until 1883.

An associated company was formed to carry the line northwards towards Cheltenham, and

the section to Cirencester was opened at the end of 1883. In an attempt to attract more capital to finance completion of the line, the companies amalgamated in 1884 to form the Midland & South Western Junction Railway, but the parlous state of the finances soon resulted in the new company going into receivership. Nevertheless, money was finally found to complete the link through to Cheltenham in 1891.

With matters going from bad to worse, Sam Fay was appointed General Manager in 1892. Within a few years, he had put the company back on its feet, even establishing its own works at Cirencester. The arrival of the army on Salisbury Plain in 1898, with the building of Tidworth branch to the new army barracks, brought considerable extra revenue. The best years of the line were the decade up to the First World War, when express trains, hauled by locomotives in their dark red livery, and containing through carriages from the north of England, could be seen passing goods trains carrying milk from the Vale of the White Horse farms, vegetables from southern England or the Channel Isles, stone from the Foss Cross quarries, and racehorses from the Marlborough Downs stables.

During the First World War, the MSWJR (nicknamed the 'Tiddley Dyke' by GWR men) carried very heavy military traffic: war supplies south and wounded men north. But traffic fell away after the armistice, and after a miners' strike in 1921 had caused services to be cut, they were only partially restored after the strike was settled. As a final irony, the Railways Act (1921) gave the MSWJR into the hands of its old adversary, the GWR.

The GWR took control towards the end of 1923. The GWR restored the passenger trains between Swindon Town and Swindon Junction, which had been withdrawn in 1885 as an economy measure, but otherwise did little to encourage traffic over the line. Cirencester works was closed in 1926.

The 1939–1945 war again saw the line carrying considerable military traffic, but services were steadily run down after the war. In 1958, through passenger trains were reduced to one per day, and the northern terminus was changed from Cheltenham Lansdown to Cheltenham St James, eliminating the possibility of connection with trains to the north. General closure followed in September 1961.

Goods traffic continued for a few years over some sections of line, with roadstone for the M4 motorway being taken to Swindon Town as late as 1971. Today, the only part of the MSWJR line used for commercial traffic is the section between Ludgershall and Andover, which still carries Army supplies. The station sites at Cirencester and Swindon have been developed for other purposes, but the former MSWJR offices still exist at Swindon. The trackbed between Rushey Platt and Swindon Town and between Chiseldon and Marlborough has been converted into a pathway. Live steam has now returned to the MSWJR at Blunsdon, where the Swindon & Cricklade Railway are working towards the re-opening of the section between Moredon and Cricklade.

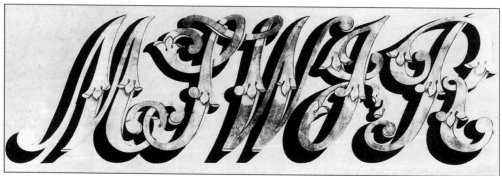

MSWJR EMBLEM. This stylish scroll was introduced in 1913 as a replacement for the plain lettering carried on locomotives. Script was in gold, with black shading, as on the panel in Swindon Railway Museum.

One
The Cheltenham
Connection

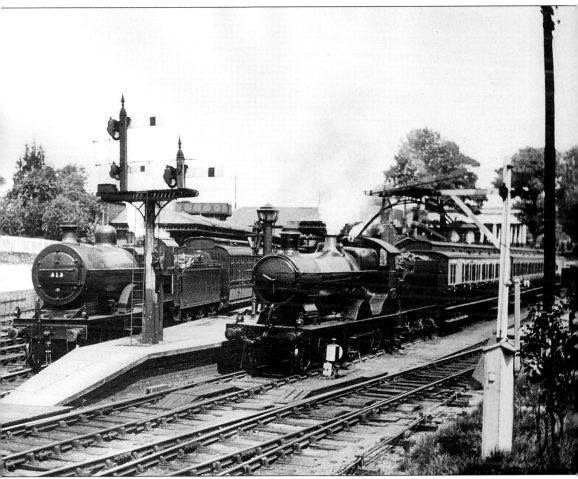

THE CHELTENHAM CONNECTION illustrated in May 1928. London, Midland & Scottish Railway 4-4-0 No. 513 stands at the main platform at Cheltenham Lansdown with an express from the north. Meanwhile, an ex-MSWJR 4-4-0, newly rebuilt by the Great Western Railway with a taper boiler and renumbered 1120, waits in the bay platform with a train for Southampton. In the heyday of the line, the fastest train completed the 96 mile journey to Southampton in 2 hours 44 minutes.

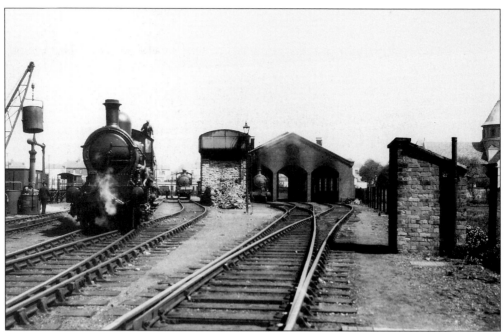

CHELTENHAM HIGH STREET ENGINE SHED, 1931. The Midland Railway had no locomotive facilties at Cheltenham, so the MSWJR provided their own in 1893. This three-road building replaced the original one in 1911. The GWR closed the shed in 1936, but the building was sold, and still survives in 1994.

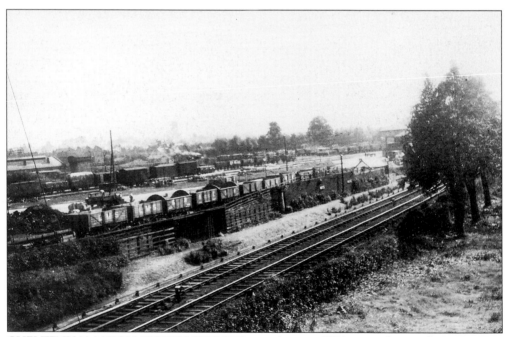

CHELTENHAM HIGH STREET SIDINGS, seen here in 1931, were the northern terminus for MSWJR freight trains. Much of the traffic came from further north, the wagons being worked through by the Midland Railway.

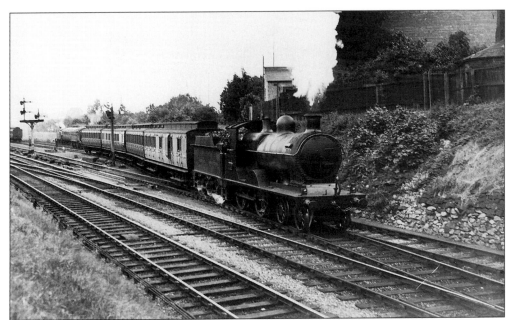

SOUTHWARD BOUND. Ex-MSWJR 4-4-0 No. 1119 draws forward from the carriage sidings immediately north of Lansdown station with her train of elderly GWR coaches, ready to start the journey down to Southampton. The date is probably 1934. The sidings are still used today for stabling passenger trains, but the route to Swindon is now via Gloucester, Stroud and Kemble.

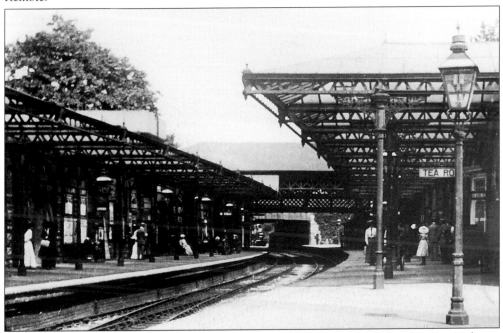

CHELTENHAM LANSDOWN STATION, on the Midland Railway's Birmingham–Gloucester line, was the starting point for MSWJR passenger services to the south. Until 1923, a notice to the right of the Tea Room advised passengers to change to the MSWJR for a wide variety of destinations, including Southampton Docks, the Isle of Wight, and even Paris.

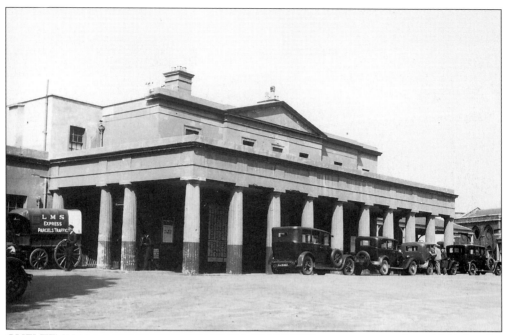

CHELTENHAM LANSDOWN STATION BUILDING was constructed in 1841 for the Birmingham & Gloucester Railway. It resembled a country house, with an imposing colonnade, as shown in this nineteen-thirties view. Like the MSWJR, the colonnade has long since gone, but the basic building still remains to serve trains on the Birmingham–Gloucester line.

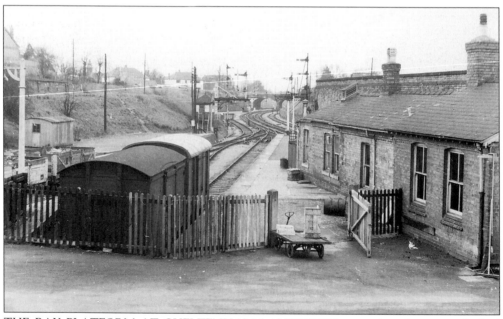

THE BAY PLATFORM AT CHELTENHAM LANSDOWN, sometimes known as Ladies' College Bay, was added in 1891, when the station was enlarged to accommodate the MSWJR trains. After the Second World War, it was used for goods traffic, as seen here. The area is now a car park.

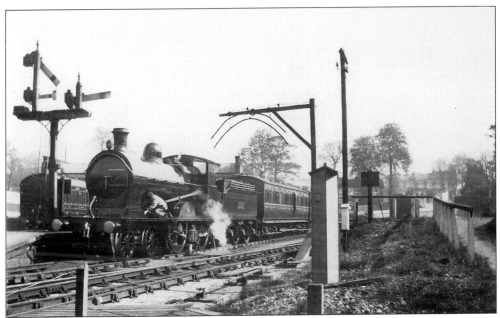

AN MSWJR 4-4-0 WAITS IN THE BAY just after the First World War. The curved strips hanging from the post on the right were used to check that loads were not oversize. Two strips were needed because the Midland Railway and MSWJR loading gauges were different.

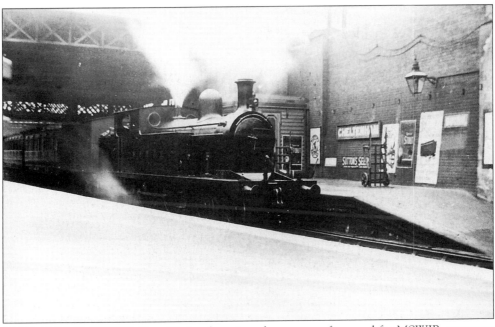

THE MAIN PLATFORMS at Cheltenham Lansdown were often used for MSWJR passenger trains. In this Edwardian view, the MSWJR 4-4-4T has steam to spare after her arrival at her destination.

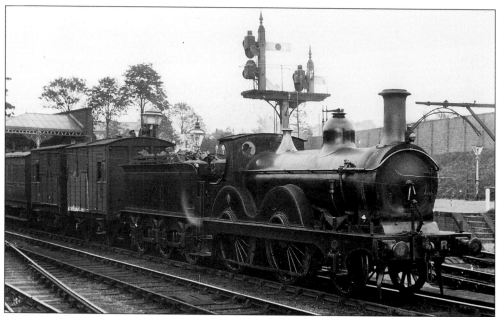

LANSDOWN STATION not only served the town of Cheltenham, but also provided a valuable connection with the Birmingham–Bristol line of the Midland Railway. The two horse boxes at the head of this Midland Railway train are MSWJR vehicles. The date is around 1906.

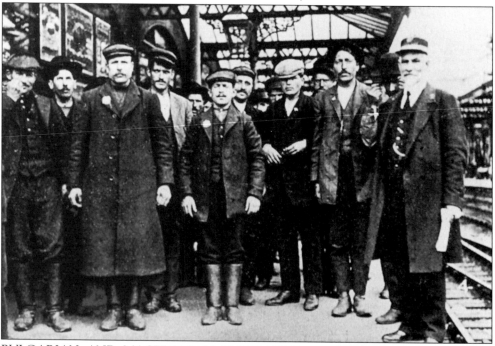

BULGARIAN AND MACEDONIAN EMIGRANTS provided an unexpected boost to MSWJR traffic on 2 May 1912, when their ship, the *Olympic*, became strikebound in Southampton. Having completed their journey over the MSWJR, they are waiting at Cheltenham for a Midland Railway train to take them on to Liverpool. They sailed for the United States in the *Cedric* the following day.

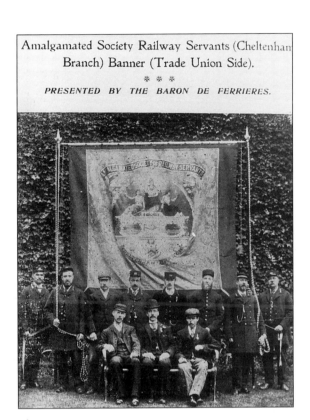

Amalgamated Society Railway Servants (Cheltenham Branch) Banner (Trade Union Side).

* * *

PRESENTED BY THE BARON DE FERRIERES.

CHELTENHAM RAILWAYMEN had their own branch of the Railway Servants Trade Union. The MSWJR representative in 1902 was guard F. Brown, seen here second from the right of the picture, holding the rope.

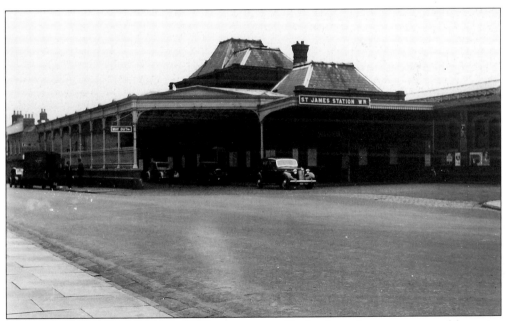

ST JAMES STATION was the GWR terminus in Cheltenham. It was never used by trains from the MSWJR route until 1958, when British Railways severed the direct connection between the Banbury line and Lansdown station. For the next three years, MSWJR line trains terminated at St. James's, until services were finally withdrawn in September 1961.

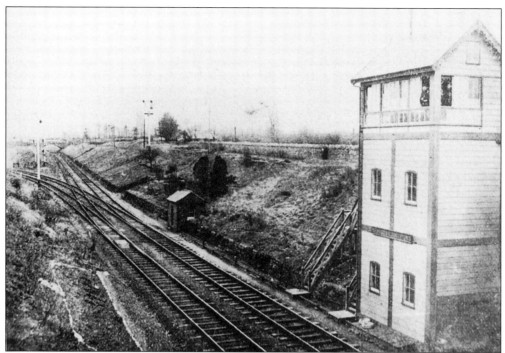

LANSDOWN JUNCTION was immediately south of the station. The GWR line on the right from Cheltenham St. James, and later Honeybourne, joined the Midland line here, to continue westwards as joint lines to Gloucester. In 1914, the tall signal cabin provided a clear view over the adjacent road bridge.

THE BANBURY & CHELTENHAM DIRECT LINE diverged away to the east from the Gloucester line just to the south of Lansdown bridge, providing the MSWJR with their route to Andoversford. Although the line was always worked by the GWR, it was nominally independent until 1897. Built as a single track, it was doubled in 1902 to help cope with the MSWJR traffic.

16

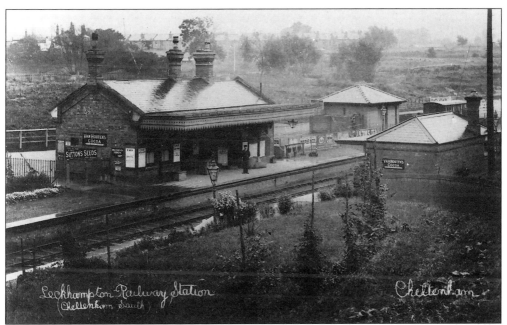

LECKHAMPTON STATION was provided with an excellent service. After 1904, MSWJR trains serving Southampton and Cheltenham, with connections to the north, were able to call, and from 1906 onwards the station was also served by GWR trains between Newcastle on Tyne and Swansea. The latter ceased in 1939, services from the MSWJR line stopped in 1961, and the station closed completely in 1962.

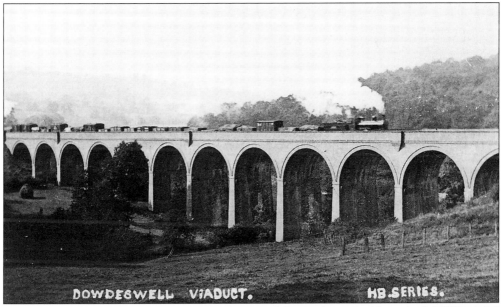

DOWDESWELL VIADUCT was a major feature of the Andoversford line. An MSWJR 0-6-0 prepares to attack the climb up to Sandywell tunnel as she crosses the viaduct in 1922 with a southbound freight. The locomotive is in all black livery, introduced as a wartime economy measure. The impending 1 in 67 gradient was steeper than the MSWJR ruling gradient of 1 in 75, and imposed a severe restriction on the weight of trains that could be handled.

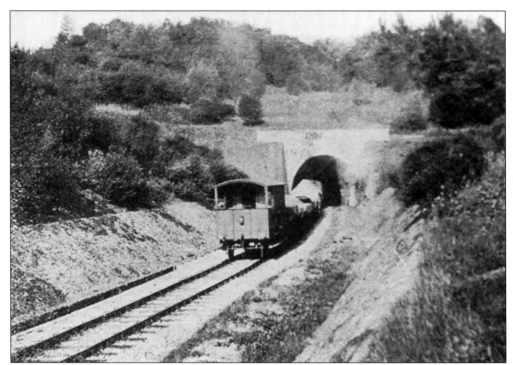

SANDYWELL TUNNEL was cut through the hill just to the west of Andoversford. A tunnel was preferred to a cutting to keep the trains hidden from the house at Sandywell Park. When this photograph was taken in 1901, the line was still single track, but it was doubled the following year.

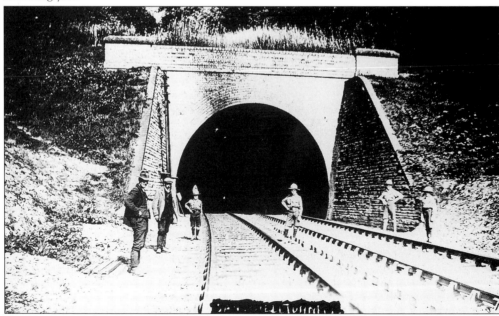

THE BOY SCOUTS ARE ON GUARD at Sandywell Tunnel, just to the west of Andoversford, in August 1914. The MSWJR route was considered a strategic link to the south, and hence a potential target for saboteurs.

THE STATION AT ANDOVERSFORD on the Banbury & Cheltenham Direct line was quite small, but would have been adequate for all village traffic. Nevertheless, friction between the rival companies meant that it could not be used by MSWJR trains until the hatchet was buried in October 1904.

ANDOVERSFORD JUNCTION was the point where the MSWJR proper began. The Banbury line goes off to the right, while the MSWJR curves through some ninety degrees to turn towards Cirencester. Companies were said to enjoy running powers over other companies metals, but the MSWJR can hardly have enjoyed the hostile treatment it received from the GWR during the early days. GWR trains were always given priority at the junction, and MSWJR trains were not allowed to stop at the stations. The MSWJR therefore built its own station immediately beyond the road bridge at the bottom of the picture. The Andoversford by-pass now follows the line of the MSWJR around the village.

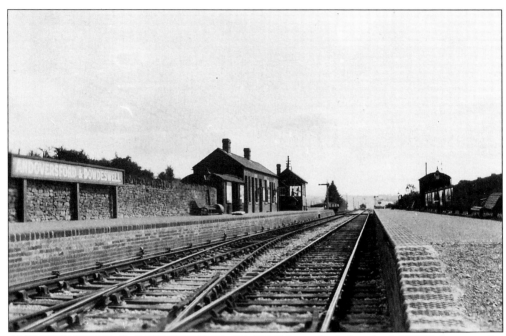

ANDOVERSFORD & DOWDESWELL STATION was built by the MSWJR because the GWR refused to allow MSWJR trains to use the B&CDR station in the village. In 1891, it served as a temporary terminus for freight from Swindon. When through passenger services began in 1891, a temporary turntable was installed here to allow engines to be turned.

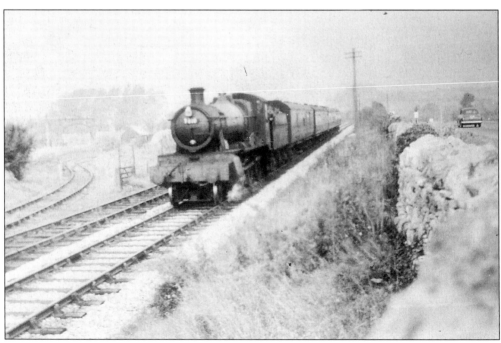

DOWDESWELL STATION was closed to passengers in 1927, but remained open for freight even after the closure of the MSWJR route, finally succumbing in 1962. Manor class 4-6-0 No. 7810 *Draycott Manor* accelerates past the old passenger platforms in 1957.

Two
Over the Cotswolds

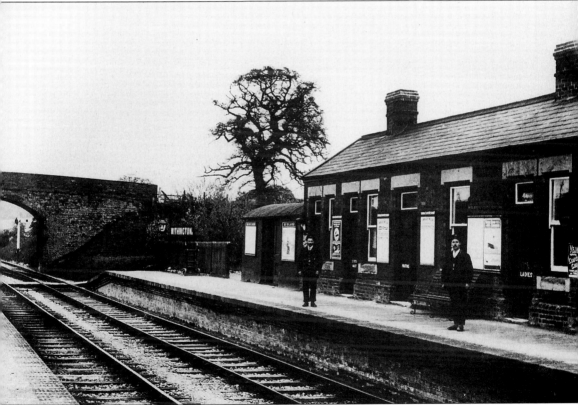

WITHINGTON STATION was never a very busy place. Station-master Lewis Harris, right, and signalman H. Curtis have plenty of time to pose for the photographer in 1912.

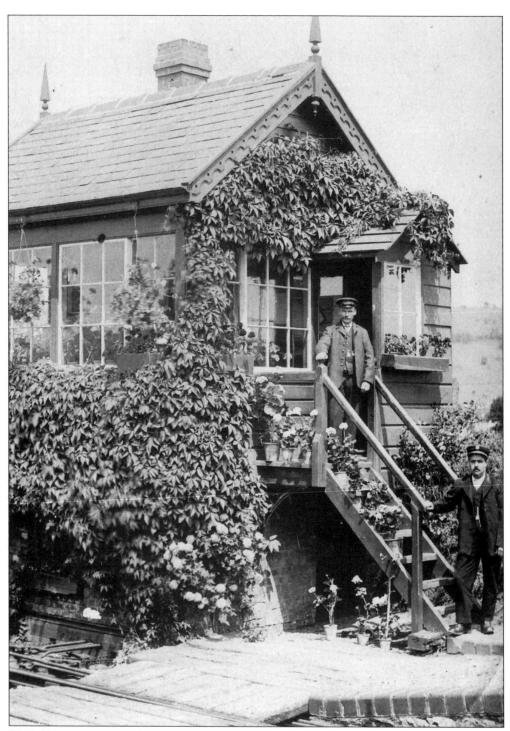

THE SIGNAL CABIN AT WITHINGTON was a riot of colour during Edwardian summers. The staff won several prizes for the signal cabin in the annual competition for the best kept MSWJR station. Signalman Curtis looks down from the porch of his cabin, while station-master Harris stands at the bottom of the steps.

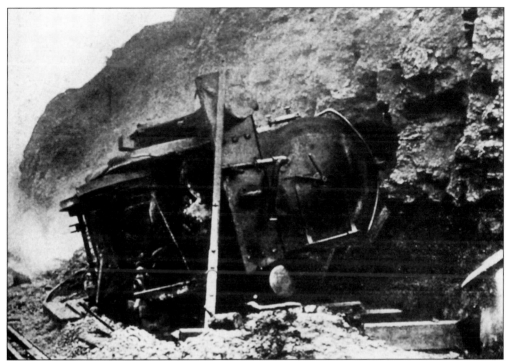

A SPECTACULAR DERAILMENT occurred between Withington and Chedworth in 1901. The cutting was being widened to add a second track alongside the original single line, and a large boulder fell from the cutting side on to the rails in front of the train. It took over six hours to clear the line and rescue the damaged locomotive, 2-4-0 tank engine No. 8.

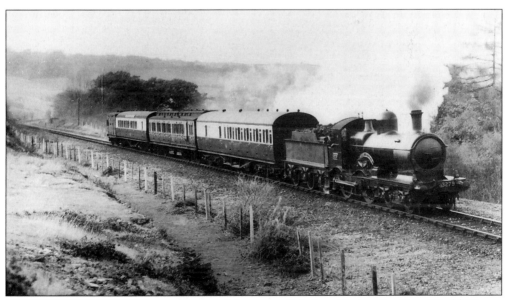

CHEDWORTH WOODS were a potential source of timber. During the First World War, a pair of sidings was put in between Withington and Chedworth Tunnel. The sidings were located in the foreground, finishing in a concrete stop block off the right hand edge of the picture. The timber was hauled to the sidings over temporary two-foot gauge tracks.

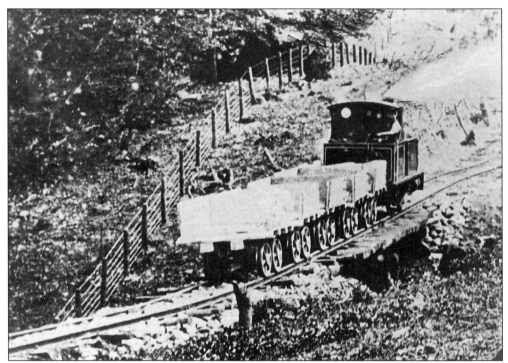

CONSTRUCTING THE LINE close to Chedworth Roman Villa. When the line opened, an excursion was run from Cheltenham for visitors to the villa, but the excursionists were refused admission. Perhaps Lord Eldon was extracting revenge for damage done to his property during construction of the line.

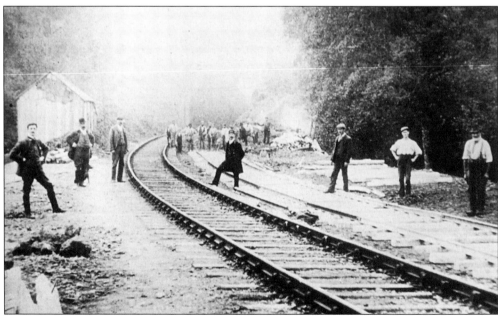

THE NORTH END OF CHEDWORTH TUNNEL during the doubling of the line in 1901. The tunnel was built to accommodate double track, but at first only a single line of rails was laid. The second line is a temporary one laid to help carry out the widening work.

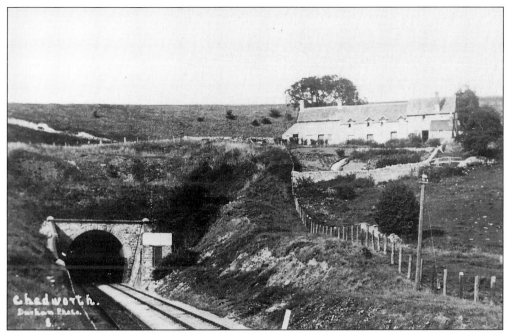

THE TUNNEL AT CHEDWORTH fell in during its construction in 1890, and delayed the opening of the line until the following year. In this 1903 view, it is just possible to make out the dip in the hillside above the tunnel mouth caused by the fall.

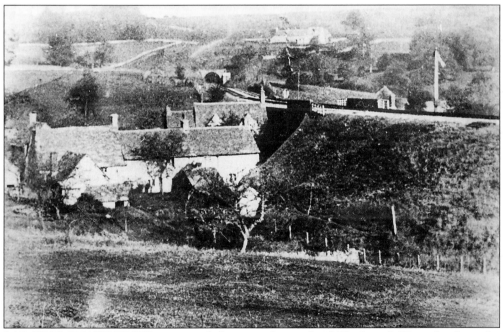

LARGE EMBANKMENTS were needed just to the south of Chedworth Tunnel, where the line crossed Queen Street. The shells of several old cottages were buried beneath these embankments.

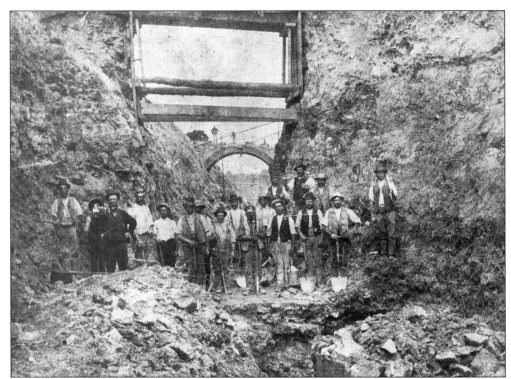

THE NAVVIES ENGAGED ON CONSTRUCTION of the line pose in a half-excavated cutting at Chedworth in the summer of 1889. The navvies lived and worked hard, and kept the local court quite busy handling charges of drunkenness, fighting, poaching, trespass, and theft. Note the partly-built bridge in the background.

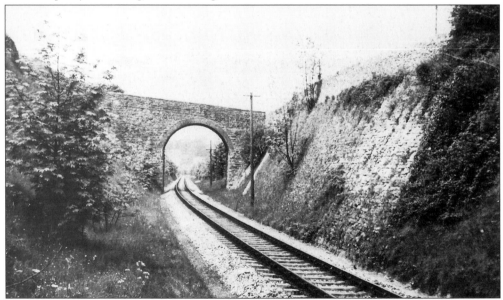

THE COMPLETED BRIDGE OVER THE CUTTING at Chedworth, as it appeared during the later years after the line had reverted to single track. This photograph is taken from almost the same spot as the previous one showing the navvies.

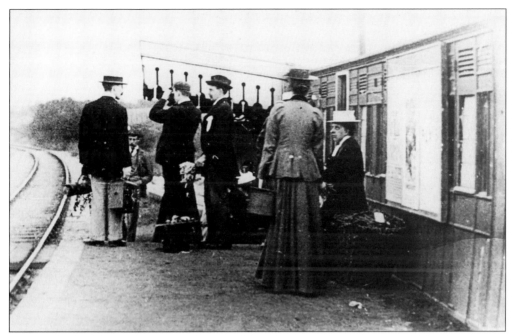

THE FIRST CHEDWORTH STATION was built in 1892 following a petition from local residents. The best the MSWJR could provide was an open shelter for the passengers and an old coach body for the staff. Nevertheless, the station was doing good business in the late eighteen-nineties. The gentleman on the left is holding an early ciné camera.

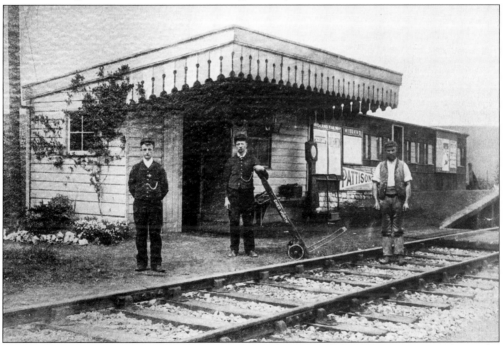

THE STAFF AT CHEDWORTH STATION at the turn of the century comprised just the station-master Frederick Tucker and porter 'Curly' Beames. The local platelayer, George Rook, completes the group.

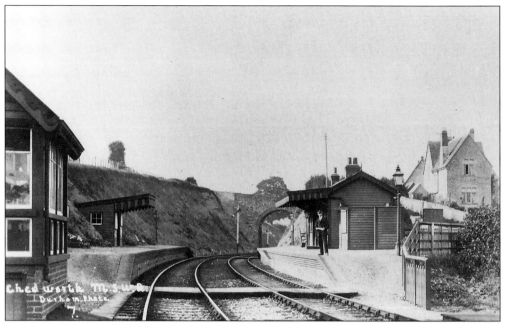

THE SECOND CHEDWORTH STATION was opened in 1902, when the line between Andoversford and Cirencester was doubled. Again, only passengers were catered for, freight still being handled at Foss Cross, but the new station did boast a signal cabin and a full set of signals.

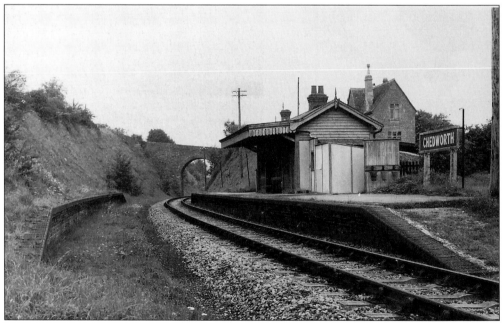

THE BASIC RAILWAY CONCEPT returned to Chedworth in 1928, when the line was reduced to single track once more. The GWR had drawn up plans to provide freight facilities at the station, but they were never implemented.

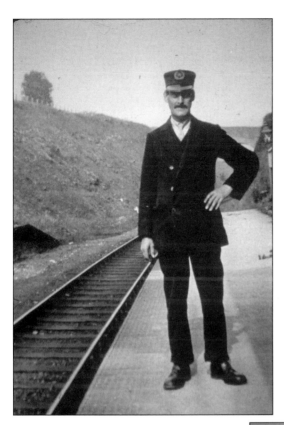

FREDERICK MILES was Chedworth station-master in 1935. The station was spared the final indignity of downgrading to an unstaffed halt until 1954.

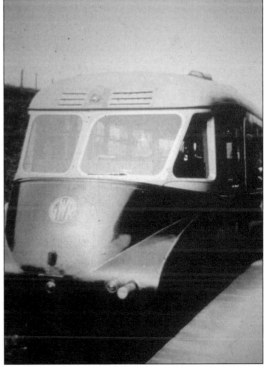

DIESELISATION WAS TRIED at an early date. A GWR railcar stands at Chedworth station in 1936. The service did not attract sufficient traffic to satisfy the accountants, and only lasted for the one year.

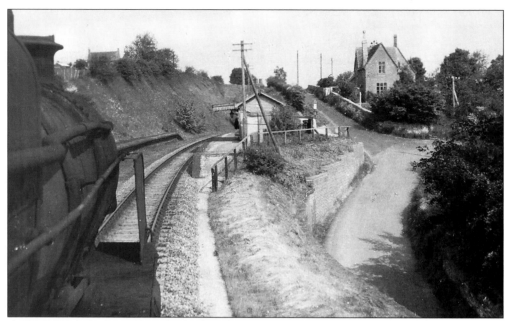

A DRIVER'S EYE VIEW of Chedworth station, as seen in British Railways days. The photograph is taken from the cab of an ex-Southern Railway mogul locomotive in charge of a Cheltenham-bound passenger train.

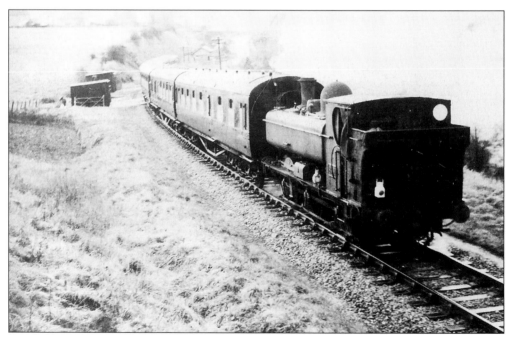

A GWR PANNIER tank engine leaves Chedworth with a southbound passenger train in the early nineteen-fifties, passing the site of the first station.

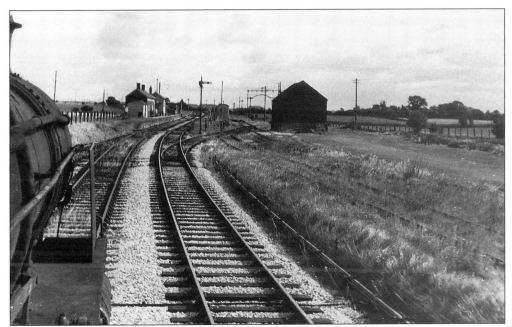

MILES FROM ANYWHERE, in open countryside, Foss Cross station was originally claimed as providing passenger and freight facilities for the villages of Chedworth, Bibury and Coln Rogers. The crew of this northbound train in British Railways days were presented with a view which had hardly changed since the opening back in 1891.

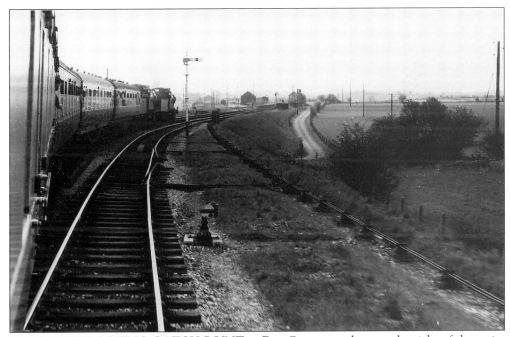

THE DOUBLE-ACTING CATCH POINT at Foss Cross, seen here to the right of the train, was intended to derail runaway wagons. It caused several unintentional derailments, particularly in cold weather when it was liable to freeze up. Staff always claimed that Foss Cross was the coldest station on the line.

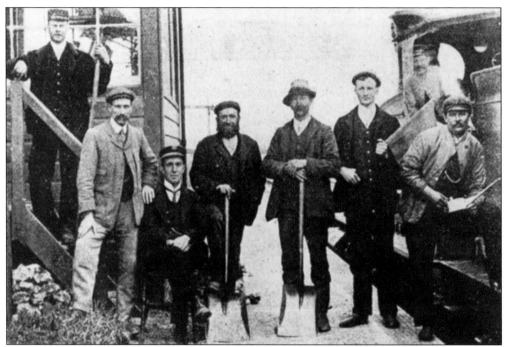

STATION-MASTER FRANCIS GILLETT, his colleagues at Foss Cross, and the crew of locomotive No. 16 take time to pose for the photographer in 1907.

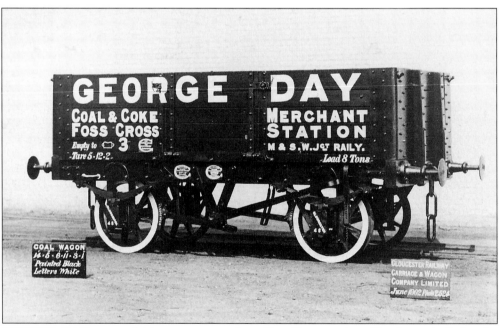

GEORGE DAY operated his own wagons from Foss Cross station. No. 3 was built by the Gloucester Carriage & wagon Co. in 1902. Mr. Day was nothing if not versatile; the 1914 Kelly's directory described him as a coal, coke and salt merchant, miller, corn factor, baker, and refreshment room proprietor.

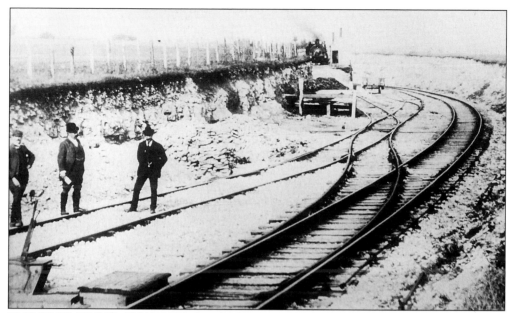

THE FOSS CROSS QUARRIES, beside the main line, provided most of the traffic at that station. At the turn of the century, the line on the right was the single track main line, with all the tracks on the left being used for quarry purposes. The quarries provided all the ballast for the permanent way.

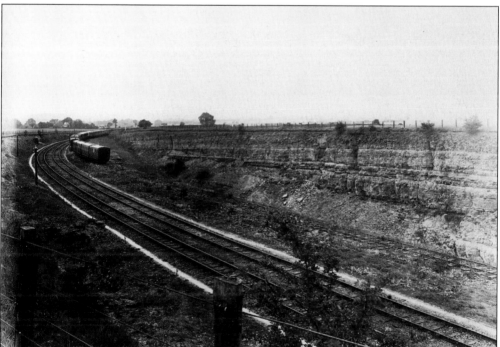

THE SCALE OF THE QUARRYING operation can be gauged in this 1926 view. The two lines in the foreground are the main running lines, the section between Andoversford and Cirencester having been converted to double track in 1902. The quarry was served by the overgrown track in the background.

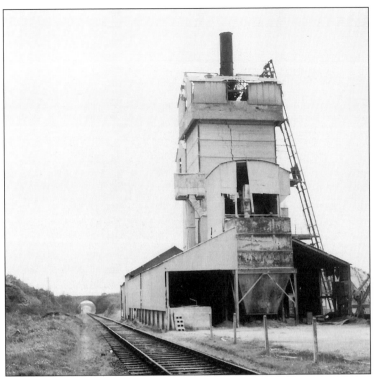

THE LIME KILNS at Foss Cross, c.1958. The kilns had been built in 1926 for the Fosse Lime & Limestone Company, just to the south of Foss Cross station. They were served by a private siding which was an extension of the line serving the cattle dock at the station. When the kilns were built, the main line was double track, but it had been reduced back to single track in 1928.

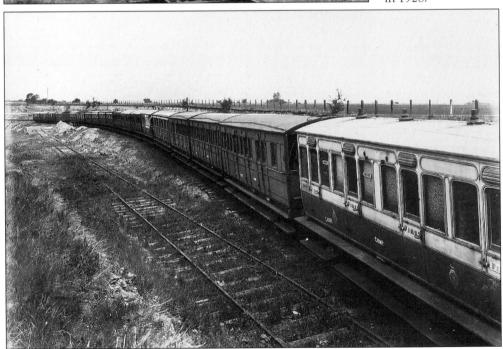

A NEW USE FOR THE QUARRY LINES in 1926 was storage of rolling stock acquired by the Great Western Railway at the railway grouping of 1922/23. The coaches nearest the camera are from the Taff Vale and Rhymney Railways in South Wales. The Taff Vale carriage now preserved by the Swindon & Cricklade Railway was probably stored at Foss Cross.

Three
Cirencester

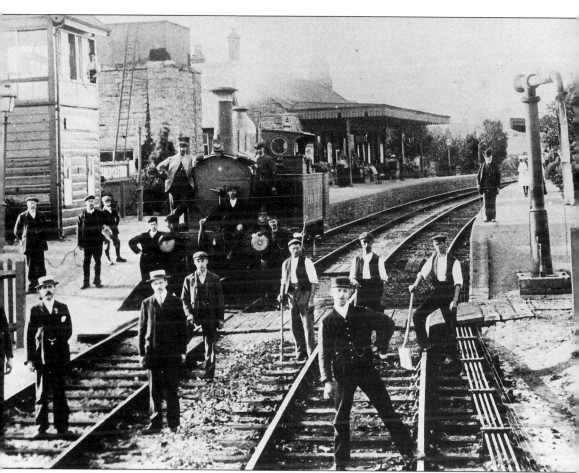

CIRENCESTER (MSWJR) STATION c.1906. The locomotive is one of the Beyer Peacock 2-4-0 tank series Nos. 5 to 7. As usual during this period, when the photographer appeared everyone else came out to have their photograph taken. The water tank shown on the platform to the left was replaced by a much larger one containing 15,000 gallons in 1912 when the supporting pier was itself greatly strengthened and extended (see p.50). After takeover by the GWR the station was renamed Cirencester (Watermoor) in July 1924, on the same day as (Town) was added to the name of the other GWR station at Cirencester.

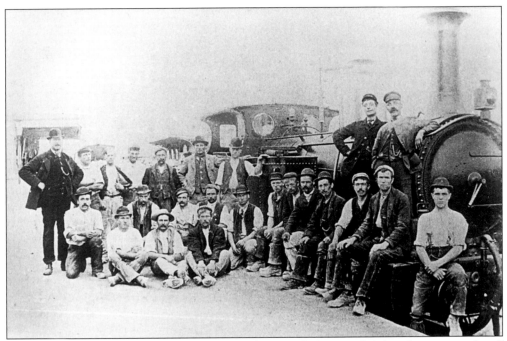

CIRENCESTER (SCER) STATION c.1891. Photograph showing 2-4-0 tank engine and staff possibly taken shortly after completion of the Swindon & Cheltenham Extension Railway from Cirencester to Andoversford in the spring of 1891.

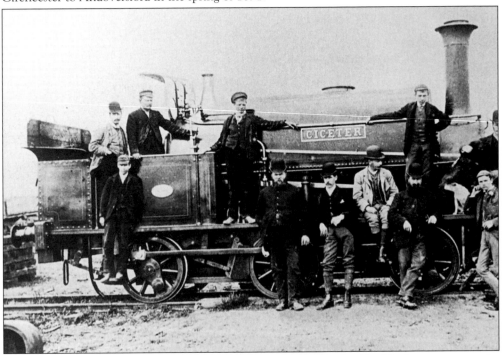

MANNING WARDLE 0-6-0ST *Ciceter*, belonging to Charles Braddock, contractor for Cirencester to Cheltenham section of the MSWJR, standing in works depôt at Norcote, just north-east of Cirencester, c.1889.

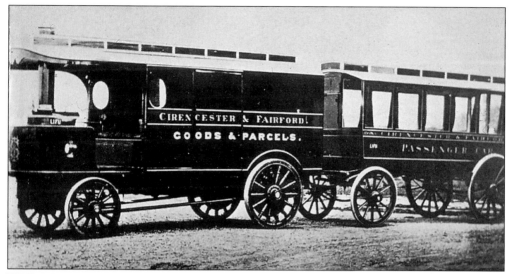

THE 'ROAD TRAIN', an oil-burning steam-driven motor van that was capable of carrying up to 3 tons of parcels and drawing a trailer with 20 passengers. Designed by H.A. House and built by the Liquid Fuel Co. of Cowes, Isle of Wight, it operated between the MSWJR station at Cirencester and East Gloucestershire Railway at Fairford from March 1898 until late autumn 1899. The adhesion was not good: passengers often had to transfer to the parcel van to improve it or get out and walk!

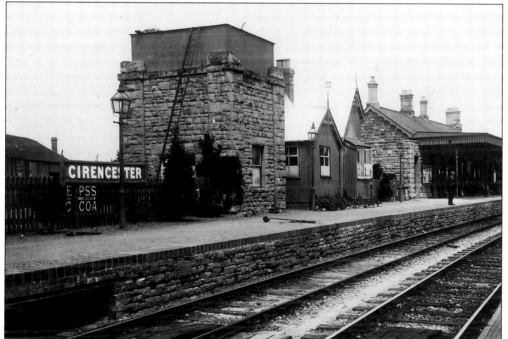

CIRENCESTER (MSWJR) STATION, from the south, c.1910. The original water tank is still in position. The corrugated iron building adjacent to the tank was the original station-master's house, subsequently used by James Tyrrell, MSWJR Locomotive, Carriage & Wagon Superintendent, and Eben Connal, resident Civil Engineer. The Company's engineering drawings were produced here. See also p.47.

VIEW TO MSWJR LOCOMOTIVE & CARRIAGE WORKS, from entrance to Isolation/Fever Hospital, Bridge Road, Cirencester, c.1900. Station buildings are top right. Due to the expense incurred by the Company sending their engines to London for repairs (locomotives were sent to LSWR works at Nine Elms), in 1895 the MSWJR set up its own repair shops at Watermoor.

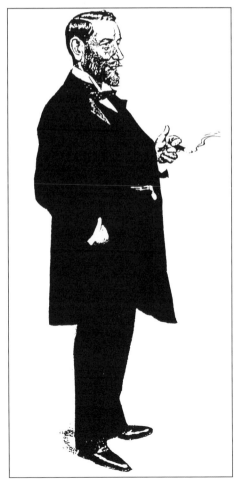

SAM FAY, General Manager and Secretary of MSWJR from 1892 to 1899. This vigorous, far-sighted railwayman transformed the fortunes of the company during his years at the helm. During his period in charge the Works at Cirencester were opened, and the Marlborough & Grafton railway was built. He later joined the great Central Railway and again made this near bankrupt line a paying concern. Knighted in 1912, he lived to the age of 96, dying in 1953. A magazine cartoon by 'Spy' for *Vanity Fair* in 1907.

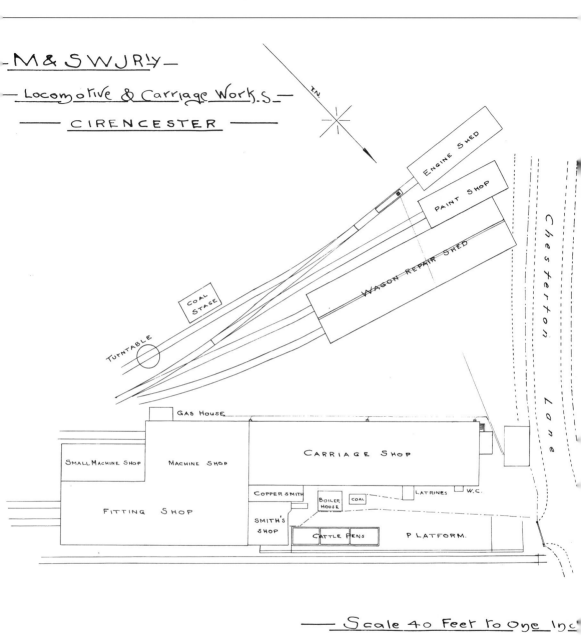

MSWJR LOCOMOTIVE AND CARRIAGE WORKS, Cirencester, April 1916. In addition to the engine repair facilities of 1895, the company built carriage and wagon shops in 1900 and enlarged the works in 1903 and 1915.

Midland and South Western Junction Railway.

APPRENTICESHIP INDENTURE.

This Indenture witnesseth That *William Gladstone Phillips, son of Harry Phillips 3. Watermoor Villas, Cirencester Glos.*

hath put and bound, and by these Presents doth put and bind himself Apprentice to the General Manager of the Midland and South Western Junction Railway Company (hereinafter called "Master") and after the manner of an Apprentice to serve from the *Twenty fourth* day of *June*, One Thousand Nine Hundred and *Twelve*, unto the full end and term of *Five* Years, from thence next ensuing, and fully to be complete and ended; during which term the said Apprentice his Master's Secrets shall keep, his Commands readily obey; Hurt to his said Master he shall not do, nor willingly suffer to be done by others; the Goods of his said Master he shall not waste or lend to any person; at Cards, Dice, or other unlawful Games he shall not play; Taverns, Inns, or Alehouses he shall not frequent; nor from the service of his said Master absent himself; but in all things shall and will soberly, diligently, truly, and faithfully serve his said Master as an Apprentice, and respectfully behave himself to his said Master or his Deputy during the said Term. And the said Master, in consideration of the due and faithful Service of the said Apprentice, and also in consideration of the sum of ———Pounds to be paid to him by———the—————————of the said Apprentice, that is to say, ——————— Pounds on the date hereof, the Receipt whereof is hereby acknowledged, and the residue on the———day of ——————One Thousand Nine Hundred and———shall teach, instruct, and inform the said *William Gladstone Phillips* or cause him to be taught, instructed, and informed in the Art, Trade, or Mystery, and every Matter and Thing therein, of a *Boilersmith* The said *Harry Phillips* agrees to find unto the said Apprentice, Meat, Drink, Lodging, and all other necessaries, during the said Term, and the said Master also shall and will pay to the said Apprentice the sums of money following, videlicet:

Five shillings — per week during ~~the last months of~~ the first year,
Seven shillings + sixpence per week during the second year,
Ten shillings — per week during the third year,
Twelve shillings + sixpence per week during the fourth year.
Fifteen shillings per week during the fifth year.

In Witness whereof the said Parties to these Presents their Hands and Seals have subscribed and set, the *twenty fourth* day of *June*, One Thousand Nine Hundred and *Twelve*.

Received, on the day of the date of the within-written Indenture, of and from the within-named ——— the sum of ——— Pounds, being part of the Consideration Money within mentioned, expressed to be paid by the said ——— to the Company.

Witness, ———

Signed, sealed and delivered, in the presence of *W. J. Mason*

W. G. Phillips (L S)

H. Phillips (L S)

James Tyrrell (L S)

MSWJR WORKS APPRENTICESHIP INDENTURE, 1912. The normal fee was £35, which was usually waived for sons of company employees, a valuable concession when even station-masters were only receiving about £5 per week.

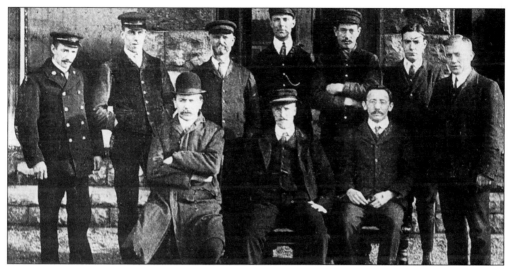

CIRENCESTER (MSWJR) STATION STAFF, 1910. Back row (left to right): signalman Miles, porter Harris, foreman Cole, porter Ockwell, porter Smith, A.S. Hinks, W.J. Perrott. Sitting (left to right): T.E.R. Morris, F.W. Dunford (station-master), W.C. Maslin. Mr. Dunford was station-master from 1905 to 1913. James Cole was later station-master at Chedworth. T.E.R. Morris was promoted to station-master at Cirencester in 1915, moving on to Bilson Junction in 1925.

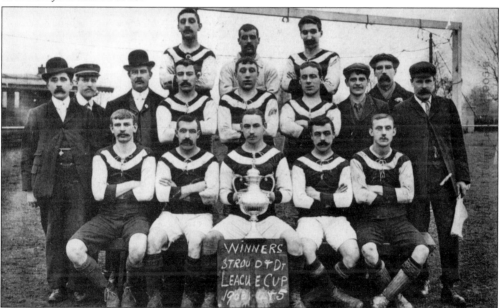

THE M&SWJR ATHLETIC A.F.C. 1905-6. The 'railers' achieved the distinction of being the first football team to bring a cup to Cirencester when they won the Stroud & District League Cup in 1903-4. On 30 April 1904, over 100 enthusiasts, including the works band, accompanied the team to Brimscombe to play the pick of the League and to receive the cup. The 'railers' won 5-1. It is reported that a tremendous crowd greeted the team on their arrival back in Cirencester, with a concert being held at the Club's headquarters, the Foresters' Arms, in the evening. The following season the team again finished at the head of the table, but were eventually deprived of the cup for fielding an ineligible player in two matches.

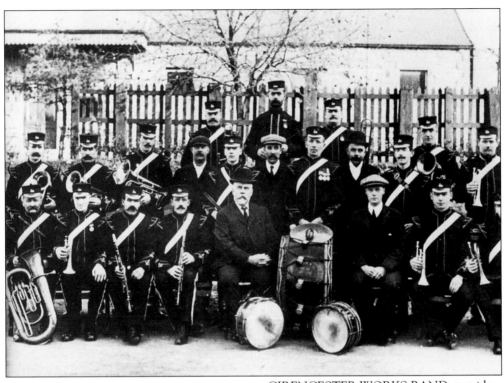

CIRENCESTER WORKS BAND, outside MSWJR station at Watermoor, Christmas 1908. The band was formed in 1903 with money loaned by James Tyrrell, Locomotive Superintendent of the MSWJR, and others for the purchase of uniforms and second-hand instruments. Mr. Tyrrell (bearded man in front row next to drum) was also vice-president of the band (see also p.149). The band became well-known throughout Gloucestershire and was much in demand for concerts, fêtes, parades and sporting events.

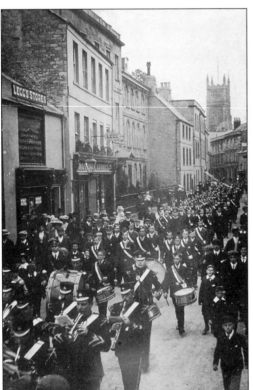

MSWJR WORKS BAND, parading through Cirencester, c.1910. In 1908 the band led a procession from Watermoor station to collect money for railway charities, and Mr. Lewis, the conductor, was presented with a silver and ebony baton at Dyer Street Congregational Church for the band's work.

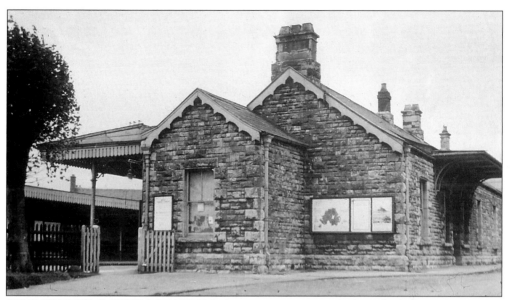

CIRENCESTER (MSWJR) STATION, showing entrance to platform, looking south, October 1919. During World War I countless troop trains arrived here, loaded with the wounded from France. These soldiers were taken by horse-drawn carriages to the Bingham Hall, where their wounds were administered to by local doctors and nurses.

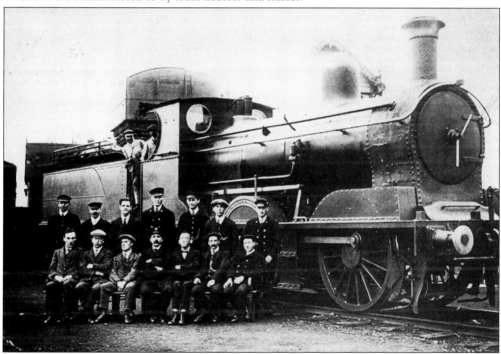

CIRENCESTER STATION STAFF & MSWJR 0-6-0 No. 20, c.1923. On locomotive: driver C. Parker and fireman Bert Lockey. Standing (left to right): Cyril Barlow, Ernest Cook, Fred Ruddle, Fred Ruck, Arthur Shill, Arthur Webb, Fred Leach. Sitting: Fred Durham, Frank Arthurs, George Roberts, Thomas Morris (station-master, see also p.41), W.C. Maslin, Harold Miles, James Bowles.

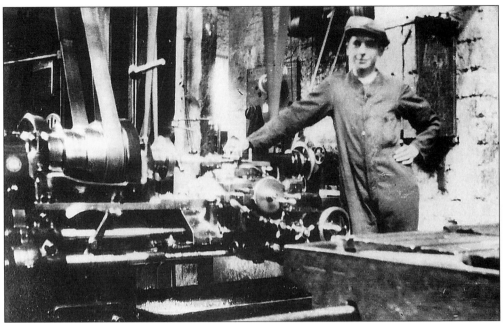

MSWJR APPRENTICE in Cirencester Works, c.1922, on belt-driven centre lathe in machine shop.

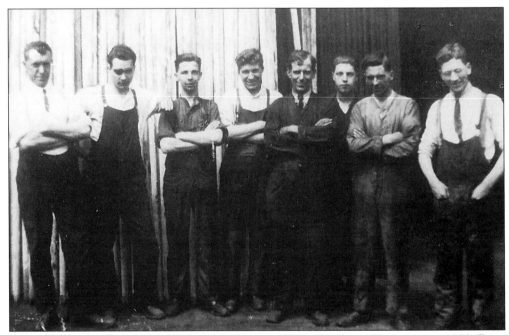

GROUP OF FITTERS AND APPRENTICES in MSWJR Works at Cirencester, c.1922. From left to right: Jim Toogood (leading fitter), Bill Bowman (fitter), -?- , Bren Waters (apprentice), Dick Miles (fitter), -?- , -?- , -?- . Behind the group is set of tubes from an engine boiler awaiting descaling.

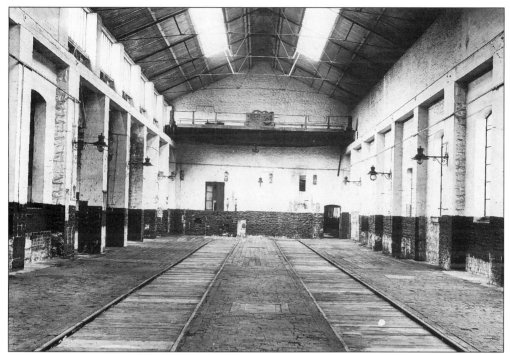

INTERIOR OF CIRENCESTER WORKS locomotive shop, May 1926. Note the 25-ton overhead travelling crane. After takeover, the GWR transferred the workforce to Swindon in 1925 and used the buildings for storage purposes.

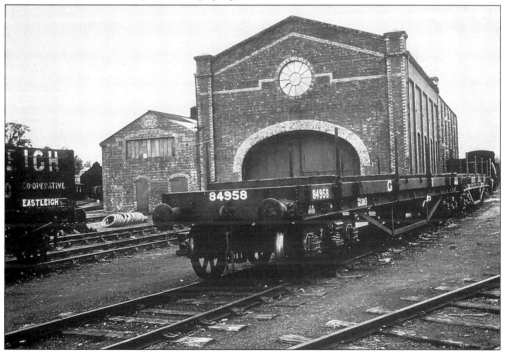

CIRENCESTER WORKS, view from yard, 1931. Note the coal wagon from Eastleigh. The goods shed is on the right.

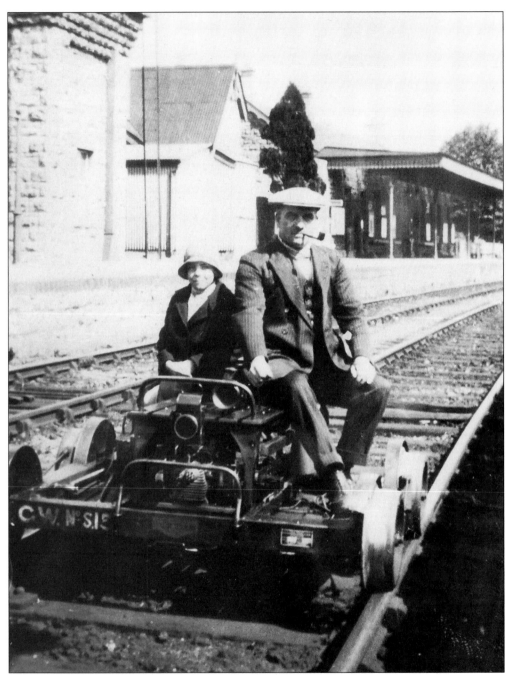

ERNEST NEALE, ganger, on petrol-driven motorised trolley in Cirencester (Watermoor) station, c.1930. On the trolley with Mr. Neale is his youngest daughter, Mary. The GWR introduced this 'motor economic' maintenance system for conveying men and tools in 1929. Mr. Neale and his trolley appeared on a cigarette card, one of a series dealing with railway subjects, which were in packets of W.D. & H. O. Wills' 'Gold Flake'. Mr. Neale died in 1964 at the age of 82 years.

NEVILLE CHAMBERLAIN, with W.C. Maslin, station-master at Cirencester (Watermoor), 1938. Mr. Maslin was station-master there for eighteen years, from 1928 to 1946.

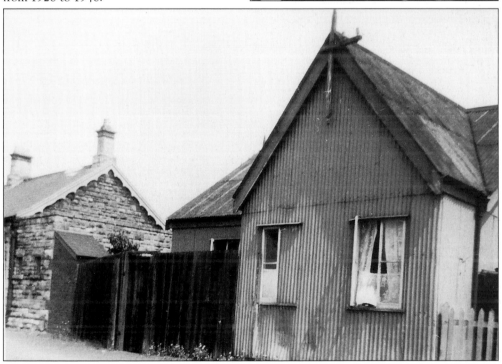

'STATION HOUSE', Cirencester (Watermoor) station, c.1944. At this time this corrugated iron structure was lived in by Mr. Neale, ganger. The outside skin was painted beige but the interior walls were lined with wood. Interior lighting was by gas, but the three bedrooms and the scullery had only candles! See also p.37.

REAR OF CIRENCESTER (WATERMOOR) STATION, looking north, August 1948. German P.O.W.s were sometimes brought into the station during World War II en route to their prison camp, Siddington Hall, the station being heavily guarded at this time and placed 'out-of-bounds' to local people.

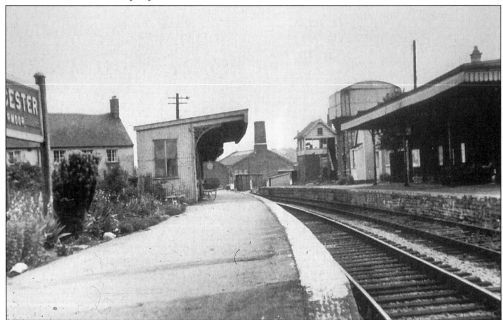

CIRENCESTER (WATERMOOR) STATION, looking south to gas works, c.1960. By this time, the area around the old machine shop of the former MSWJR works was covered in scrap cars. Until the 1970s, the old carriage shop was used by an engineering company. The whole area was redeveloped in the late 1970s when the Cirencester by-pass road was built.

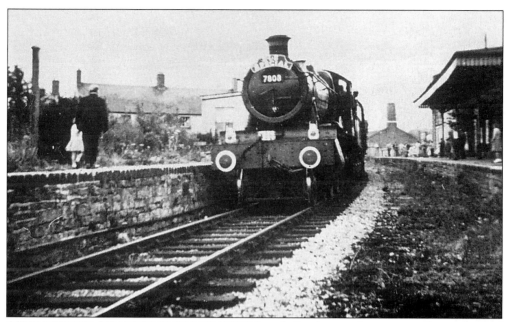

CIRENCESTER (WATERMOOR) STATION, with Stephenson Locomotive Society special train on last day of passenger service, 10 September 1961. The train was hauled by ex-GWR 4-6-0 No. 7808 *Cookham Manor*.

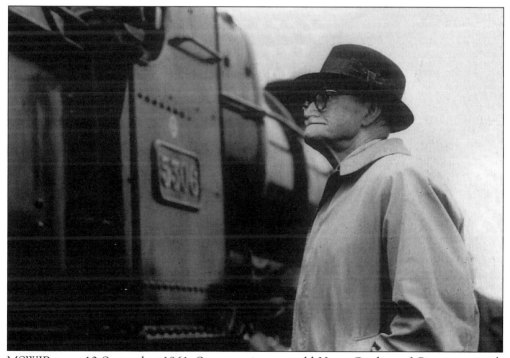

MSWJR tour, 10 September 1961. Seventy-nine-year-old Harry Gardner of Cirencester with locomotive of the Railway Correspondence & Travel Society special at Cirencester on the last day of passenger services.

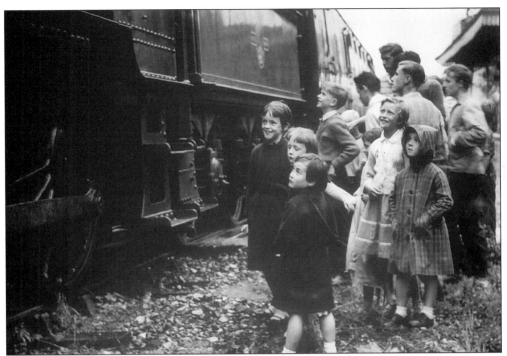

Ex-GWR 43xx class 2-6-0 No. 5306 at Cirencester with R.C.T.S. special train, 10 September 1961. Children watching the end of the railway era on the MSWJR.

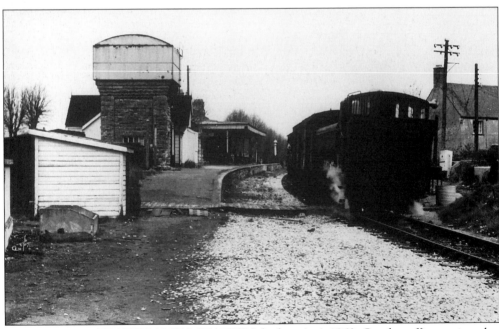

CIRENCESTER (WATERMOOR) STATION, looking 'up', 1963. Goods traffic continued at Cirencester until April 1964. Compare the large water tank, fitted in 1912, with the one in earlier views (see pages 35 and 37).

Four
Into North Wiltshire

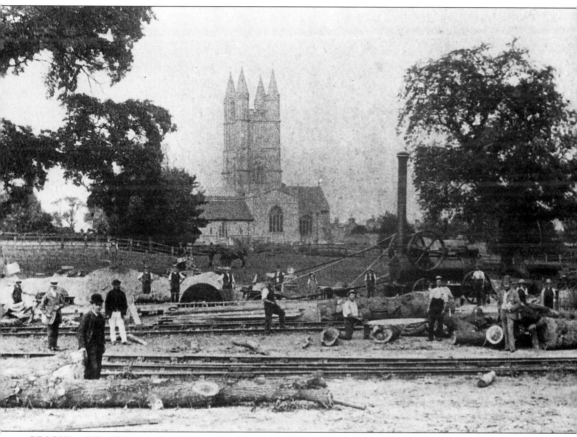

CRICKLADE STATION SITE AND ST. SAMPSON'S CHURCH, 1883. A view taken at north-west end of site, the track in the foreground being the main running line, and the one further back leading to a goods shed sited just to left of photograph. The traction engine was driving a circular saw for timber for general constructional purposes in new station building and goods shed. Watson, Smith & Watson were contractors for the Swindon & Cheltenham Extension Railway which opened between Rushey Platt and Cirencester in December 1883. The town of Cricklade celebrated the opening of the railway with a luncheon at the White Hart Hotel, with sports and fireworks in the evening.

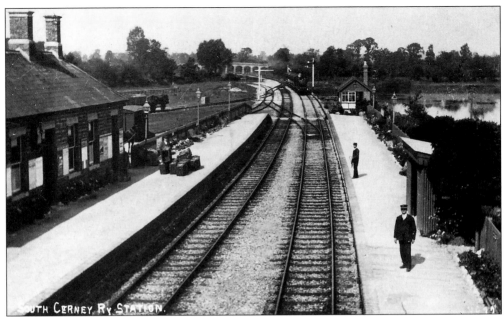

CERNEY & ASHTON KEYNES STATION, looking north, c.1907. The station did not have a passing loop and signal cabin when first opened in 1883, these being added in 1900. The name was later shortened to Cerney, probably when new nameboards were provided in 1910.

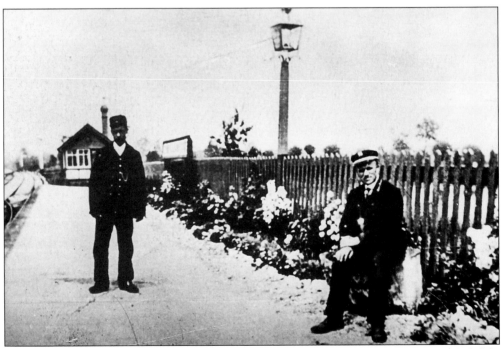

SIGNALMAN COOK AND STATION-MASTER BOWDEN at Cerney station, c.1910. Mr. Bowden was station-master at Cerney from 1895 until 1925.

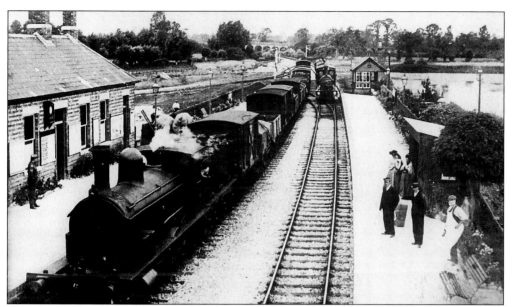

CERNEY STATION at an unusually busy period, one morning in 1913. It is a few minutes after ten o'clock, and the 9.15 a.m. stopping passenger train from Cheltenham Lansdown, hauled by 2-4-0 No. 10, has caught up with the 5.50 a.m. pick-up goods from Cheltenham High Street, headed by 2-6-0 No. 16. The goods train, which is running slightly late, has been shunted into the 'up' loop in order not to delay the passengers. Note the multi-arched bridge in the background – one of several which still stand today.

SIGNALMAN ERNEST COOK, South Cerney, 1930.

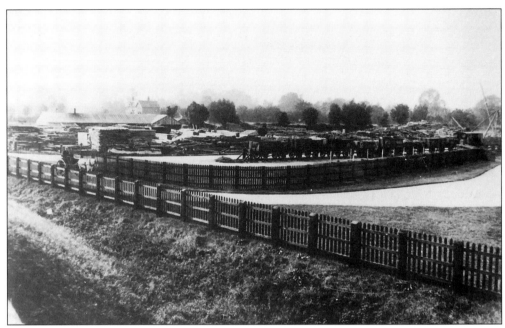

GOODS YARD, CERNEY, viewed across station approach, 1923. The station was renamed South Cerney in July 1924.

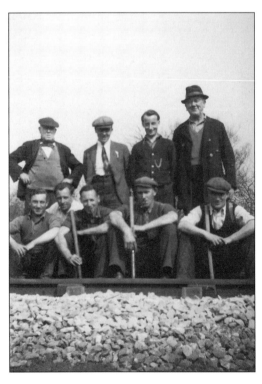

GROUP OF GANGERS, South Cerney, c.1955. Identified are, back row, left to right: Mr. Ritchins, -?-, Eddie Waldron, Mr. Mullis. Front row: -?- , Jim Lawrence, -?-, Jim Mallan, Patrick Lanney.

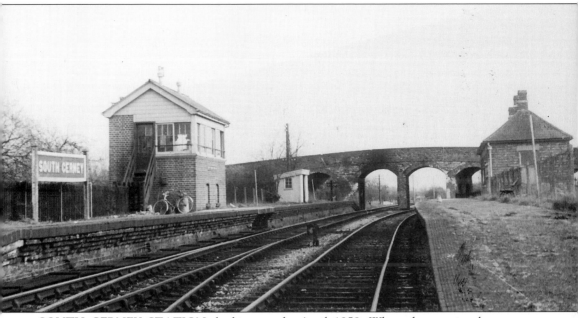

SOUTH CERNEY STATION, looking south, April 1958. When the crossing loops were extended in 1942 a standard GWR signal box was also built on the 'down' platform to replace the former MSWJR cabin. Today the station site has been redeveloped for housing and a children's play area, but the bridge shown here still exists close alongside the houses as a memory of former days.

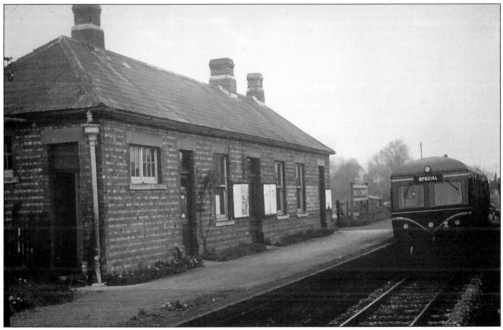

SOUTH CERNEY STATION, with DMU in station, c.1960. The DMU was being used for crew training. Normal passenger services remained steam-operated to the end. Today the footpath through the Cotswold Water Park follows the course of the MSWJR through the site of South Cerney station.

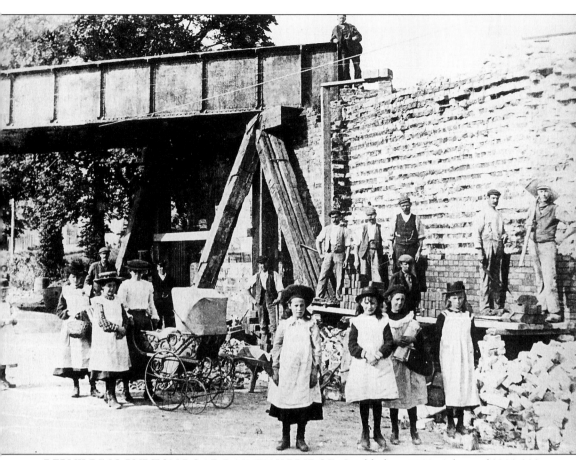

REBUILDING PURTON ROAD RAILWAY BRIDGE, Cricklade, c.1902. A loan of £200,000 – later increased to £250,000 – from the Midland Railway allowed the MSWJR to carry out many needed improvements to the line. These included strengthening bridges in preparation for heavier engines. On the northern section the line was also doubled between Andoversford Junction and Cirencester. Identified on this photograph are, at rear: Jessie Archer, John Hicks. Front, left to right: -?- , Ada Welch, Mrs. Gould, Mrs. Ackwell, Emily Sykes, Theresa Cuss, Violet Broadway, Mrs Dobbs.

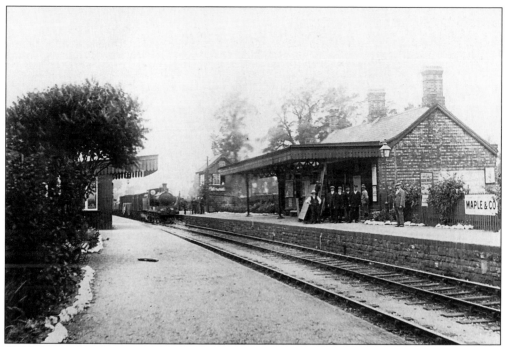

CRICKLADE STATION, c.1910, with MSWJR 0-6-0 locomotive on a goods train. Cricklade was the centre for milk traffic with 80 to 100 churns a day being dealt with by the staff. Two of the more affectionate nicknames bestowed on the MSWJR were 'The Milky Way' and the 'Milk and Soda Water'!

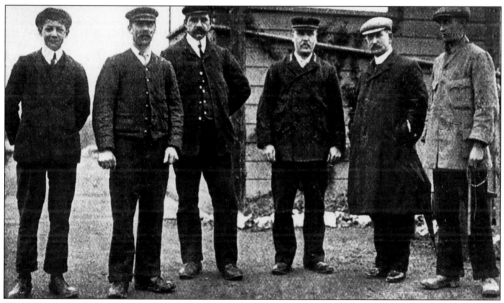

CRICKLADE STATION STAFF, April 1910. Third from right is William Walkley, station-master at Cricklade from 1904 to 1926. He was later station-master at Newnham-on-Severn.

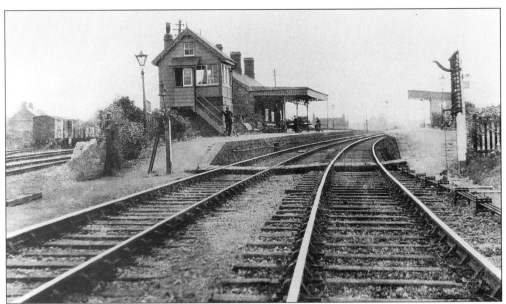

LOOKING EAST TO CRICKLADE STATION, c.1930. The house to right of station is No. 1 High Street, and that to left of wagons is 'The Leaze'.

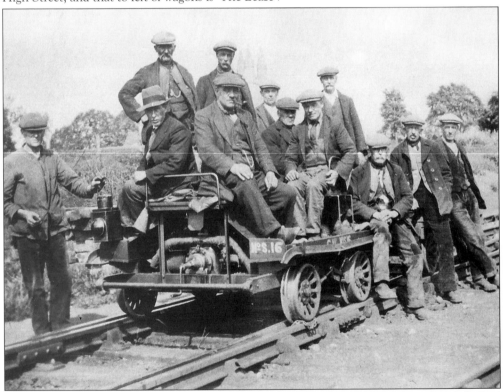

MOTORISED TROLLEY, on former MSWJR near Cricklade, c.1930. On ground, to left, Fred Gassor. Seated on trolley, on left, Inspector Pinnel, Ernest Neale. Seated on extreme right, 'Jiper' Gassor. On extreme right of photograph, Mr. Ritchins. Most of the permanent way men were picked up by trolley at South Cerney and Cricklade for work on their section.

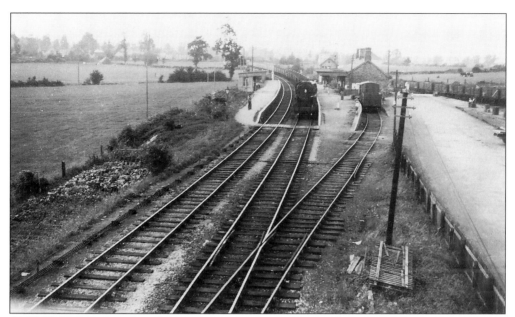

CRICKLADE STATION, looking north, August 1944, with a southbound goods train in station pulled by American 2-8-0 engine. During World War II, and especially in the months before and after D-Day, the old MSWJR line carried an immense amount of military traffic.

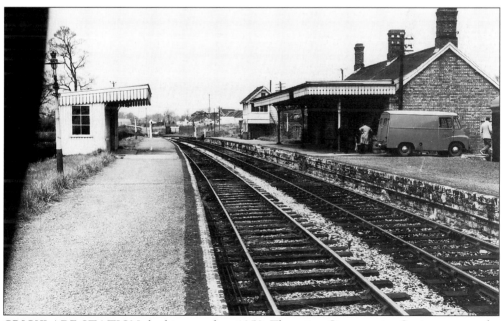

CRICKLADE STATION, looking north, c.1950. There is a Co-operative Society van on the platform on the right.

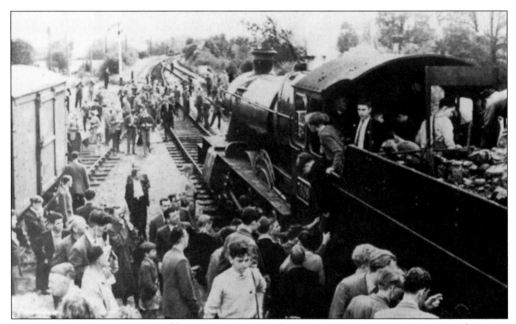

Ex-GWR 4-6-0 No. 7808 *Cookham Manor* on Stephenson Locomotive Society special tour at Cricklade on last day of passenger service, 10 September 1961. About 250 people travelled on this special enthusiasts' train from Birmingham.

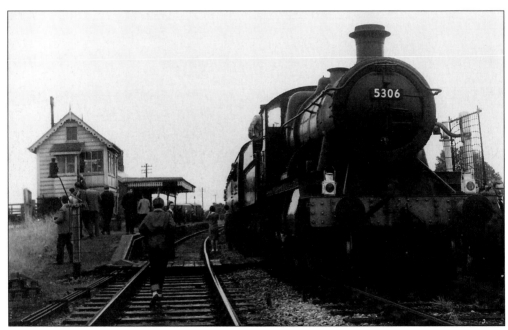

FRONT VIEW OF 43xx CLASS 2-6-0 No. 5306 on R.C.T.S. special train in Cricklade station, 10 September 1961.

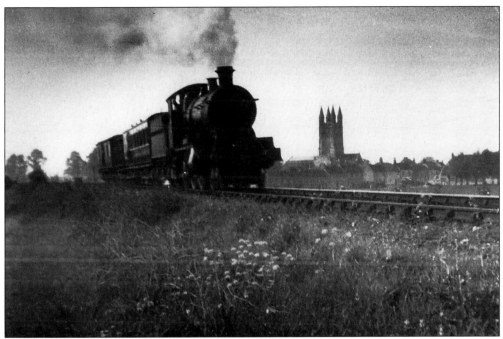

EVENING TRAIN LEAVING CRICKLADE for Swindon, 1950s. The tower of St. Sampson's church is in the background.

BLUNSDON STATION, looking towards Cricklade, 1937. Opened in 1895 by the MSWJR primarily for milk traffic, as was a nearby platform at Moredon, which opened in 1913, Blunsdon station closed to passengers after the grouping in 1924 (although for several years previously the service had been reduced to just one train per day) and to goods in 1937. It is now home to the Swindon & Cricklade Railway Society.

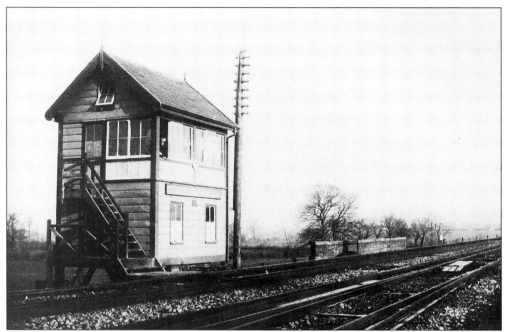

GLOUCESTER CARRIAGE & WAGON CO. SIGNAL CABIN, controlling the junction with MSWJR on north side of GWR London–Bristol line, 1882. To the right is a road bridge over the Wootton Bassett Road. The signal cabin was known as 'Swindon "K" cabin'. Note the mixed standard/broad gauge track. The passenger service between Swindon Town and Swindon Junction station was withdrawn in 1885 to cut costs, and not resumed until after the grouping in October 1923.

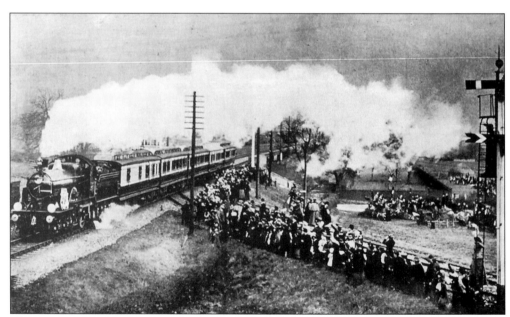

THE KING'S SPECIAL. A GWR royal train en route to the west being watched by crowds gathered along sides of the loop line to Swindon Town and embankment by road bridge, c.1902.

RUSHEY PLATT, c.1900. A smartly dressed group of men and a horse-drawn vehicle below embankment, with Gloucester Carriage & Wagon Co. signal cabin, which was on the north side of the main GWR line. Erected at the expense of the Swindon, Marlborough & Andover Railway, this controlled the junction with the GWR. See also p.62.

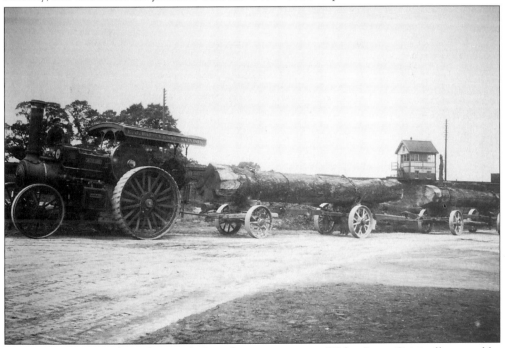

TIMBER YARD, Rushey Platt, c.1910, with traction engine *Walter Long*. Originally owned by E.J. Barnes, the yard was later taken over by a Mr. Davies. The photograph is by well-known Swindon photographer, William Hooper.

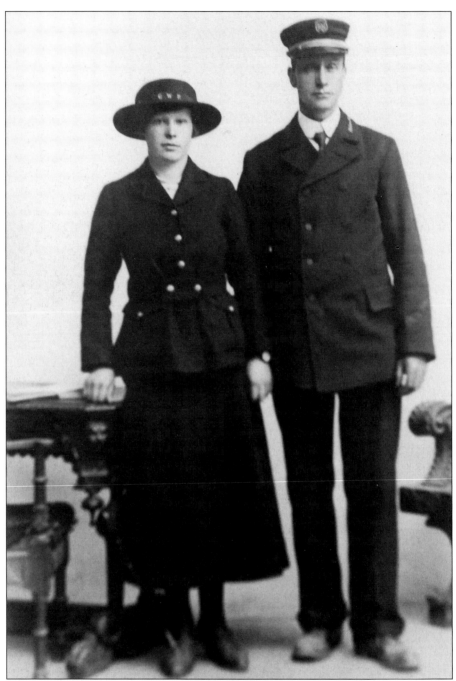

ERNEST BROWN, station-master at Rushey Platt, and his daughter, Elsie Brown, a GWR ticket collector, at Rushey Platt c.1917. Ernest H. Brown was station-master at Rushey Platt from 1914 to 1931, after having been in charge at Blunsdon, Withington and Andoversford & Dowdeswell stations. During World War I, Rushey Platt was a key point in the transfer of wounded troops from Southampton to hospitals in the Midlands and the North, and sometimes he had to superintend the despatch of as many as four ambulance specials in one day. Mr. Brown later became station-master at South Cerney from 1931 to 1934.

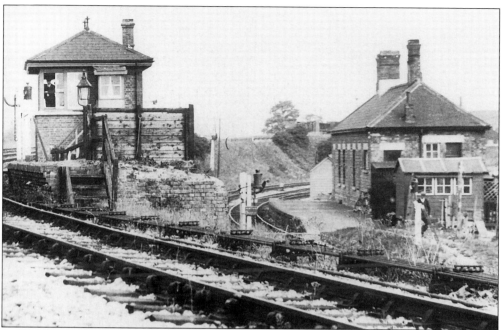

RUSHEY PLATT STATIONS, looking north, 1934. The main MSWJR line to Cricklade is to the left with two platforms; the loop line to GWR is to the right, with station buildings including the station-master's house. Note Fred Adams, signalman, looking from his cabin. The station officially closed to passengers as early as 1905, although for some years trains could still be persuaded to stop if required.

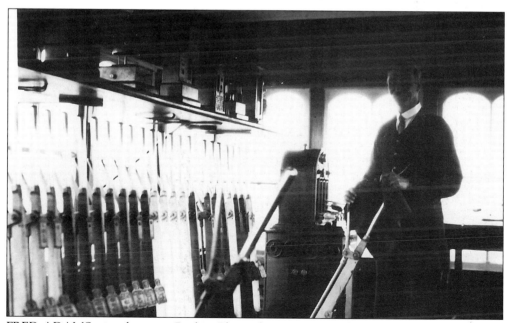

FRED ADAMS, signalman, in Rushey Platt cabin in 1934, with Stevens lever frame, GWR instruments, and token apparatus. See also p.78.

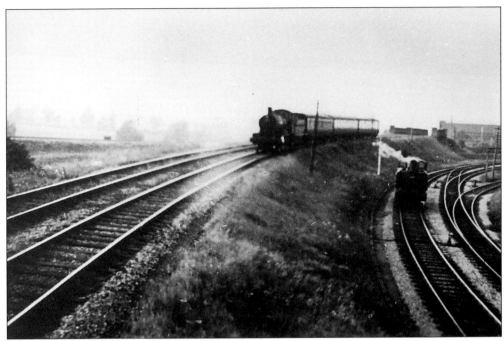

THE VIEW NORTH from Rushey Platt signal cabin, near Wootton Bassett Road, in the late 1950s. Today the trackbed between Rushey Platt and Swindon Town station site has been converted for use as a cycle way and footpath.

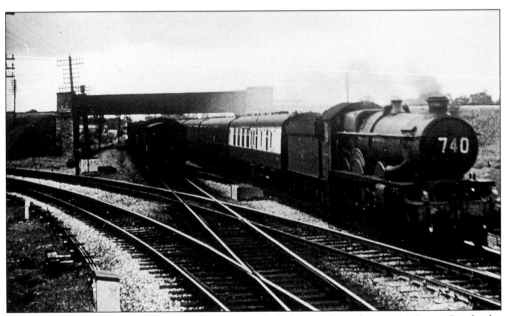

Ex-GWR 'CASTLE' CLASS 4-6-0 No. 5043 *Earl of Mount Edgcumbe* on 11.15 a.m. Pembroke Dock to Paddington train at Rushey Platt, August 1958. The curve to the MSWJR line is to the left with an overbridge carrying the line to Cricklade in the background.

Five

Swindon

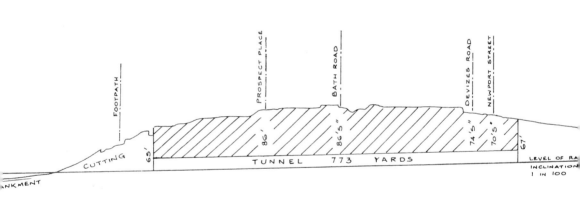

SECTION THROUGH THE PROPOSED SWINDON TUNNEL. The Swindon, Marlborough & Andover Railway began the excavation of a tunnel under the Old Town of Swindon in October 1875, despite fierce opposition from local inhabitants, who feared their wells would run dry! Workings were abandoned in 1876 after many falls and flooding, and a new route for the railway finally taken to the south of Westlecot Road. The tunnel cutting and embankment are clearly shown on the Ordnance Survey map of 1886, to west of Drove Road, where Queen's Park is today. It is said that the island in the lake is the last relic remaining of the embankment to the tunnel mouth and that tools and trucks used on the workings were buried when work ceased. In recent years similar problems to those experienced by the tunnel contractors in the 1870s have reappeared with subsidence in the area around the site of the tunnel.

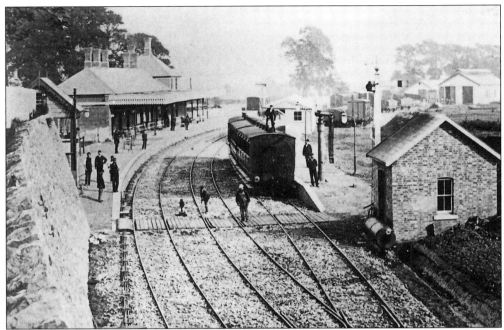

SWINDON TOWN STATION, looking east from Devizes Road bridge, 1881. For the opening of the railway the SMAR obtained seven passenger carriages from the Metropolitan Railway Carriage & Wagon Co. of Birmingham. Three of these can be seen at centre of photograph, with the oil lamps being changed. Note the ballast covering the sleepers. The rail was Krupps flat-bottomed type.

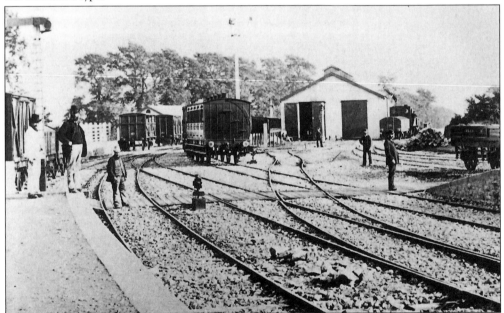

SWINDON TOWN STATION, looking south-east from 'down' platform, 1881. On the right are two open carriage trucks and a round-ended open truck. At centre background is the original engine shed. One of the original three Dübs & Co. 0-6-0 tank engines can be seen to the right of the engine shed, behind an open wagon.

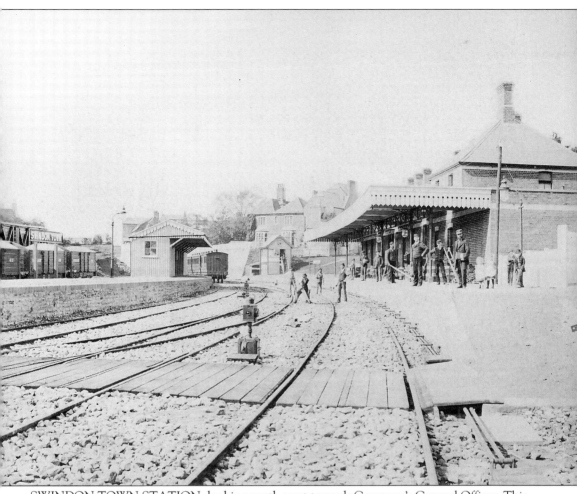

SWINDON TOWN STATION, looking north-west towards Company's General Offices. This view is one of several reputed to have been taken by the Rev. Thomas Rolph, Vicar of Chiseldon, possibly on the first day of services in July 1881. The offices were formerly the house, The Croft, of J. Copleston Townsend, the Company's solicitor. The 'A' or north signal cabin, supplied by the Gloucester Railway Carriage & Wagon Company, can be seen below the offices on the 'down' southbound platform. A footbridge was built, to replace the level crossing between the two platforms, by February 1882. In the foreground, to the right, on the 'down' platform, is Mr. J.W. Read, station-master. In connection with the opening ceremonies of the line on 27 July 1881, the streets of Old Town were lavishly decorated with flags, festoons and bunting, and a luncheon was held at the Corn Exchange with an invitation dance there during the evening. Today, the station site has been developed for light industry, but the former Company's offices can still be seen, although reduced in size, and are the premises of a firm of heating engineers.

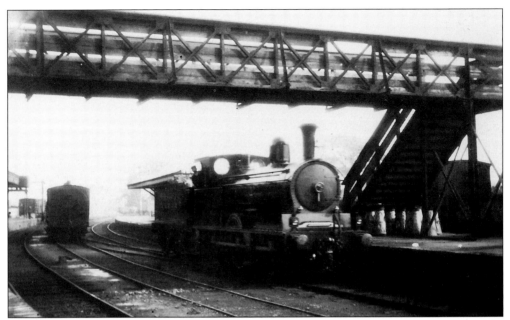

MSWJR 0-6-0 LOCOMOTIVE No. 24 at Swindon Town station, 16 September 1899. The development of increased goods traffic to Southampton led to six of these large 0-6-0 tender goods engines being purchased from Beyer Peacock of Manchester in 1899, Nos. 19 to 24.

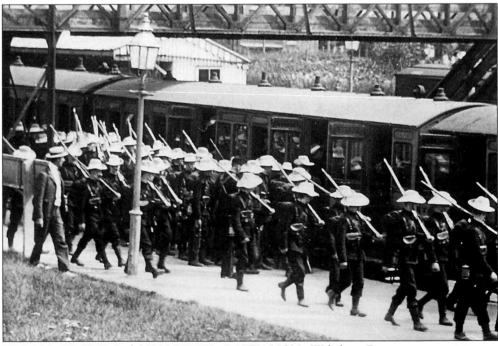

TROOPS OF THE 2nd VOLUNTEER BATTALION, Wiltshire Regiment, entraining at Swindon Town station, 3 August 1901. Five hundred and fifty volunteers left Swindon en route for Aldershot. Note the slouch hats that the men are wearing.

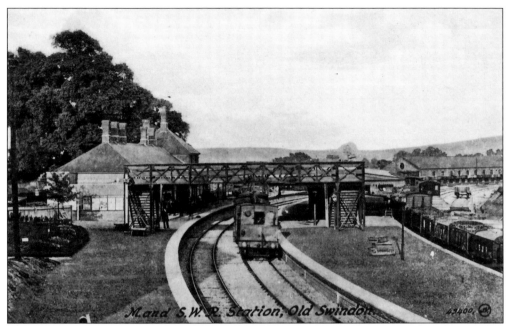

SWINDON TOWN STATION, after alterations during 1904-1906. The centre road was removed through the station and the 'up' island platform built with an additional 'up' through line being laid. The 'down' platform was also rebuilt and extended, the original engine shed (see p.68) being demolished and a new one built about half a mile to the south.

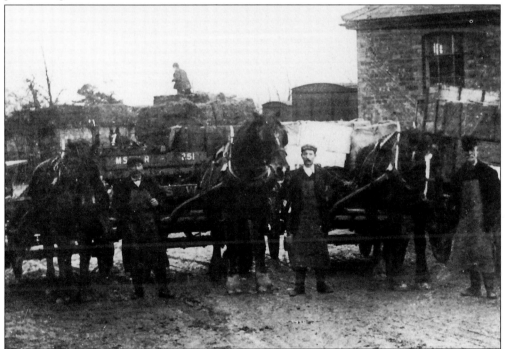

MSWJR HORSE-DRAWN WAGONS at the north end of goods transfer shed, Marlborough Road, Swindon, c.1910. To the right is the office attached to the goods shed. Today Queintin Road/Beringer Close stand on the site and the access road is now Signal Way.

AN 0-6-0 LOCOMOTIVE ON NORTHBOUND TRAIN, approaching Evelyn Street bridge, Swindon, c.1910. View taken from rear window of house in Evelyn Street.

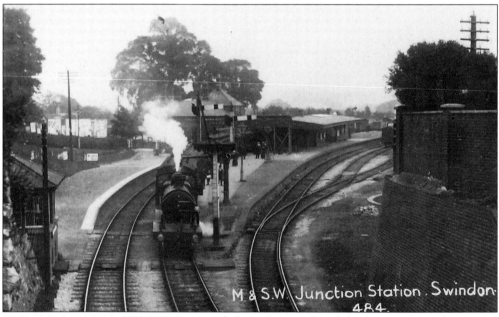

M & S.W. Junction Station. Swindon. 484.

SWINDON TOWN STATION, viewed from Devizes Road bridge, 1913, with a 4-4-0 locomotive on a northbound express. One regular duty for station staff was the release of racing pigeons sent down from northern England. On one Saturday in June 1909 a record total of 80,000 birds were sent off from Swindon Town.

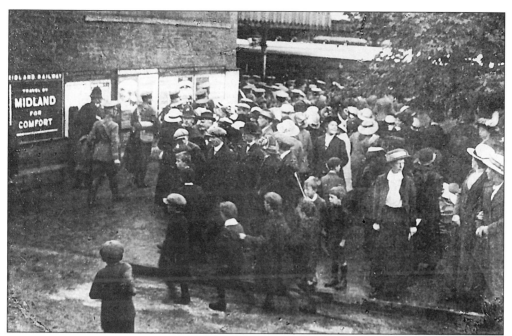

MEMBERS OF THE WILTS BATTERY AND AMMUNITION COLUMN, 3rd Wessex Brigade of the Royal Field Artillery, arriving at Swindon Town station on 5 August 1914. The contingent consisted of eighty officers and men under the command of Col. Bedford-Pim and Major the Earl of Suffolk. They are being seen off to war by their families and townsfolk. Note the advertisement for the Midland Railway.

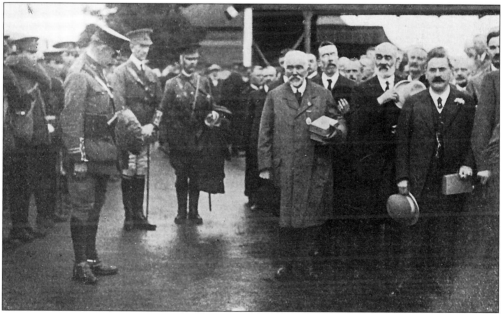

THE MAYOR OF SWINDON, Alderman C. Hill, and other local dignitaries bidding farewell to men of the Royal Field Artillery at Swindon Town station, 5 August 1914. The contingent were shortly afterwards to be sent to India, but many of the men later returned to fight in France, one of them being Sgt. William Gosling of Wroughton, who won the VC there in 1917.

73

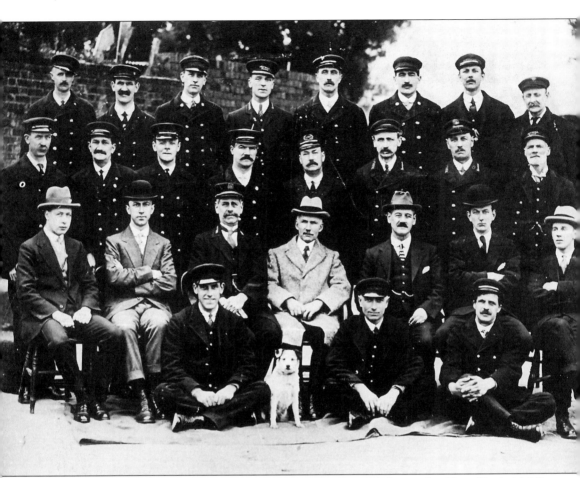

SWINDON TOWN STATION STAFF, c.1923. Back row, left to right: Tom 'Spider' Mills (shunter), Bert Brock, Charles Sheppard, Dandy Wilmott (guards), Fred Guilder, Reg Hyde (shunter), Charles Ockwell (porter), Arthur Butler (Carriage & Wagon Examiner). Second row: Fred Collins (porter), George Whitbread, Harold Spackman, Bill Walker (signalmen), Inspector H.A. Robinson, -?- , Mr. Allen (foreman), Sidney Longman (guard). Third row; -?-, -?-, Harry Baker (station-master), Chief Inspector Sam Rumbold, -?-, -?-, Major Clark. Front row: Nelson Edwards, Fred Gardner (porters), Jack Bowden (relief signalman).

Inspector Rumbold had previously been station-master at Swindon Town from 1897 to 1902. Harry Baker was station-master there from 1905 until his retirement in 1929.

It is reported that porter Nelson Edwards in MSWJR days, not being allowed to use the refreshment rooms at the station while on duty, used to have his beer lowered to him in a basket by the barmaid at the Plough public house over the cutting near Devizes Road bridge! This story is illustrated on the mural painted at the site of the station in 1985, but today it is sadly defaced and neglected.

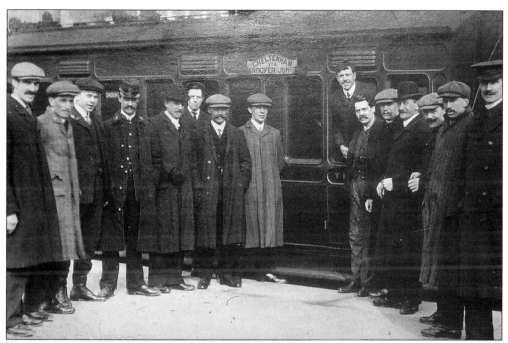

SWINDON CORPORATION TRAMWAY STAFF at Swindon Town station, c.1919, wishing 'bon-voyage' to conductor Jack Lewis, who was emigrating to Canada. Many emigrated to Canada and Australia to seek a new life after the end of World War I.

HOLIDAY CROWDS on 'down' platform at Swindon Town station, 1928. The line, giving direct access to Southampton and the south coast resorts, was always busy during the summer months, and weekend excursions to Bournemouth ran until closure in 1961.

ACCESS ROAD TO SWINDON TOWN STATION, off Newport Street, c.1920. On left is cattle market with premises of Augustus A. Hart (auctioneer) and Dore Fielder sale yard.

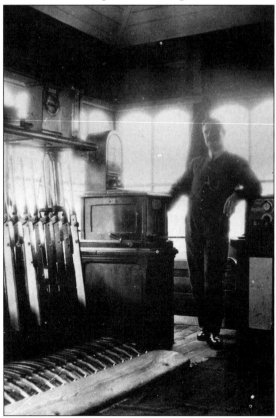

INTERIOR OF SWINDON TOWN 'B' SIGNAL CABIN, May 1929, with signalman Bill Walker. A native of Aldbourne, he came to Swindon in 1915 after working at Ludgershall and Tidworth. He was signalman at 'B' box, near Evelyn Street, for several years. See also p.2.

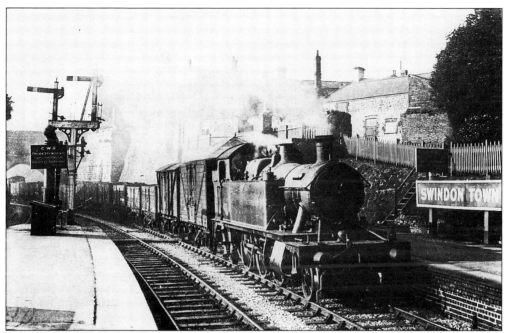

GWR 2-6-2 TANK ENGINE on goods train entering Swindon Town station from north, c.1935.

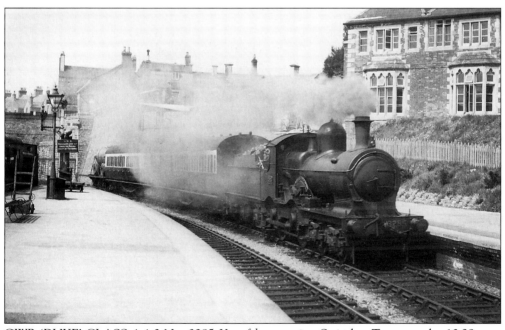

GWR 'DUKE' CLASS 4-4-0 No. 3285 *Katerfelto* entering Swindon Town on the 10.29 a.m. Cheltenham to Southampton train, 11 May 1936. To the right can be seen the former MSWJR general offices above the platform.

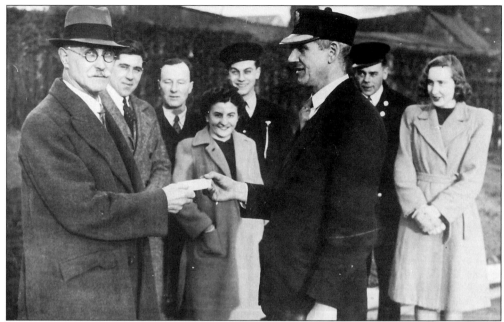

PRESENTATION TO RETIRING SIGNALMAN FRED ADAMS, at Swindon Town station, 1945. Left to right: Fred Adams, Bert Hunt (relief signalman), Arthur Willis (signalman), Nora Harris (clerk), Bill Morse (shunter), John Philpin (station-master), Trevor Allen (signalman), Joan Willis (clerk). See also p.65.

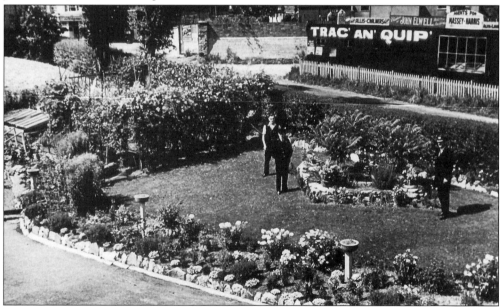

SWINDON TOWN STATION GARDEN, viewed from passenger overbridge, c.1946. Pictured with the fruits of their labours are, left to right, Bill Morse, Charles Pitman, and station-master John Philpin. To right of photograph is access road to station and entrance to cattle market next to the premises of TRAC' AN' QUIP'. On top left, through the trees, can just be seen shops in Newport Street. Swindon Town garden often received commendations in the GWR station gardens competitions.

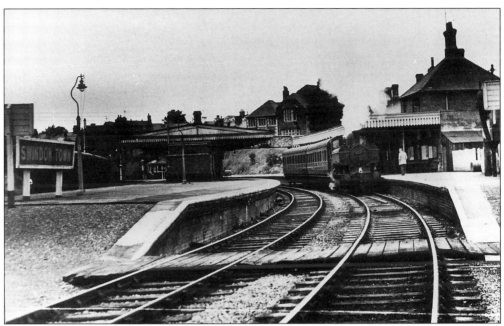

SWINDON TOWN STATION, looking north-west, with pannier tank locomotive on southbound train, c.1955.

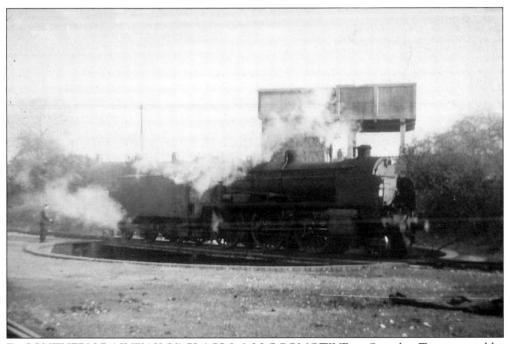

Ex-SOUTHERN RAILWAY 'U' CLASS 2-6-0 LOCOMOTIVE on Swindon Town turntable, c.1960. These engines were frequent visitors to the former MSWJR line during the British Railways era.

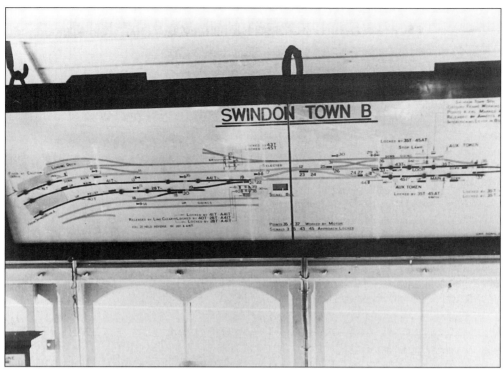

INDICATOR BOARD IN SWINDON TOWN 'B' BOX, July 1960.

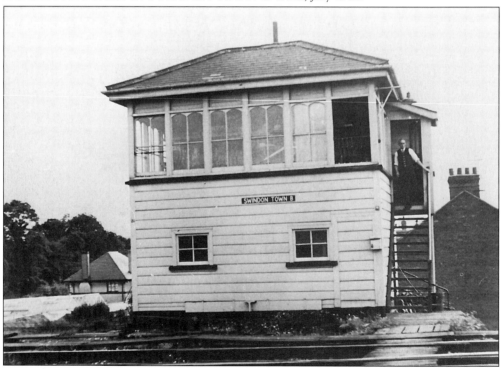

SWINDON TOWN 'B' SIGNAL BOX, near Evelyn Street, 26 July 1960. On steps of box is relief signalman Trevor Allen.

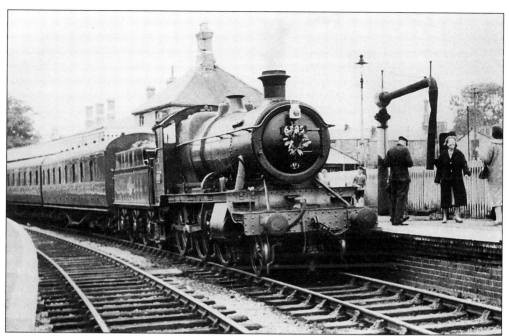

LAST SWINDON TO ANDOVER JUNCTION passenger service train waiting to leave Swindon Town station, 10 September 1961. Mrs Joan Jeffries and her daughter of Old Town made a laurel wreath which the driver hung on the smokebox door of locomotive No. 6395. The laurel wreath was still intact when the train returned to Swindon in the evening. See also p 159.

SWINDON TOWN STATION, looking east from Devizes Road bridge after closure, 1963.

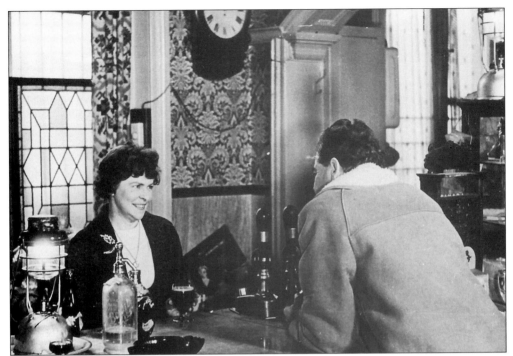

LAST DAY OF OPENING AT SWINDON TOWN REFRESHMENT ROOMS, 1 February 1965. Tom Salmon of the BBC talks to licensee Mrs Townsend. The licence was first granted in 1894, and the bar remained virtually unaltered, with gas lighting, ornately carved tables, potted palms, and a 1904 till that would only ring up a total of 2s 11½d!

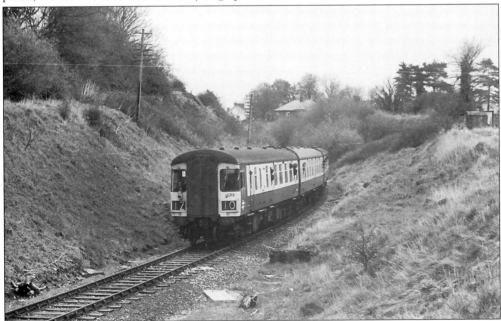

LOCOMOTIVE CLUB OF GREAT BRITAIN'S 'Somerset Quarryman' tour, 16 April 1972. Probably the last special passenger train to run into Swindon Town. The four-car inter-city DMU is photographed here in the cutting west of Devizes Road bridge.

Six
Over the Downs

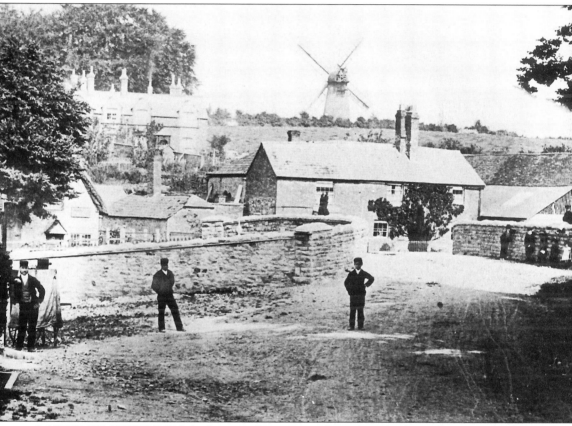

A VIEW OF CHISELDON, looking north-east over the railway bridge, July 1881. Another photograph taken around the opening day of services by the Vicar of Chiseldon, the Rev. Thomas Rolfe. The coming of the railway changed the face of the village, literally cutting it in two, completely changing the old centre, an open green backed with trees called the Square. Until the advent of the railway Chiseldon had been an entirely rural community, and every man, woman and child worked in the fields at Harvest time. On the opening day of the line, 27 July 1881, a general holiday was declared in the village, and the children of the village school were drawn up alongside the station (augmented by many of the navvies' children) to greet the special train carrying the directors of the SMAR and other officials by singing the 'Swindon, Marlborough & Andover Railway Song', under the guidance of the master. The windmill shown on this photograph now stands as the centrepiece of Windmill Hill Business Park, near junction 16 of the M4 motorway, having been taken down brick by brick and rebuilt there in 1984.

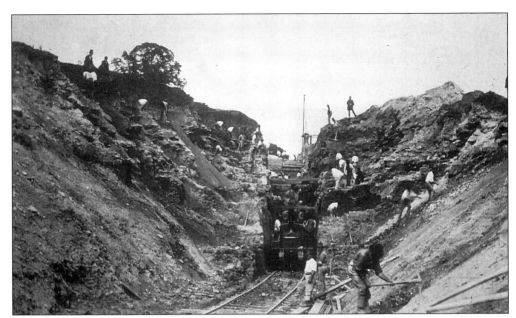

EXCAVATION OF CUTTING, Chiseldon, 1880. Messrs Watson, Smith & Watson were appointed main contractors for the SMAR in August 1879. An army of railway navvies descended upon Chiseldon in early 1880 with their families and were housed in huts nearby. Thousands of tons of chalk were dug out from two cuttings with pick and shovel by the labourers, many of whom were Irish, and carted northwards towards Hodson Woods to make embankments. At least one navvy, Billy Smith, was killed in May 1880 during the workings by a landslip when the sides of the cutting gave way. Note contractor's locomotive in photograph.

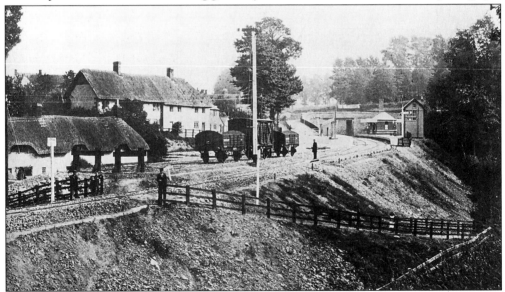

VIEW SOUTH OF CHISELDON STATION, July 1881. In the distance the signal cabin and road bridge can be seen. Buffer stops in the small goods yard seem to have been made from wooden sleepers. The coming of the railway reduced the price of coal in Swindon by five shillings a ton, a significant amount in those days, when the price per ton at the railhead would only have been around £1.

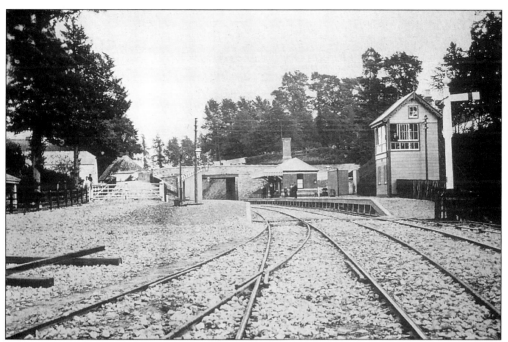

CHISELDON, view south to station, July 1881. The access road to the village is to the left next to the Elm Tree Inn.

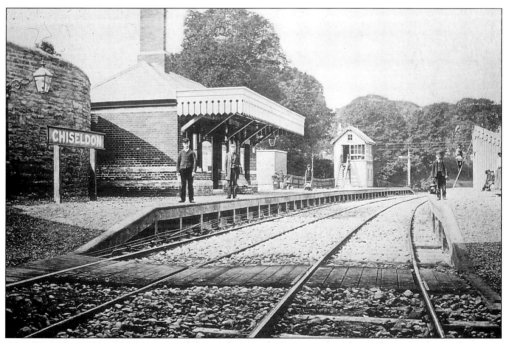

CHISELDON STATION, viewed from the north from under the railway bridge, July 1881. Note the elegant bracket lamp to the left, and the young boy carrying the lamp on the platform on the right.

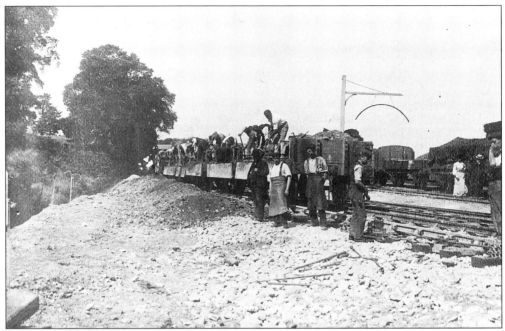

UNLOADING BALLAST FROM WAGONS, for enlarging Chiseldon station yard, c.1903/4.

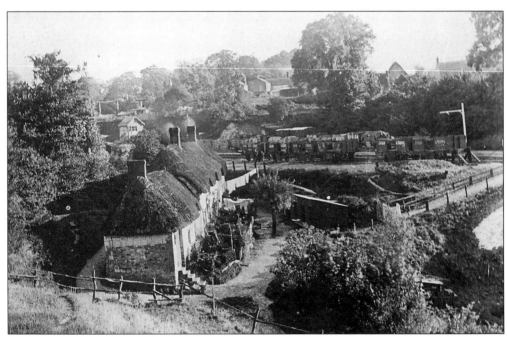

VIEW TO GOODS YARD, Chiseldon, from slope near the church, c.1900. Private owner wagons of coal merchant John Toomer & Sons are in the yard.

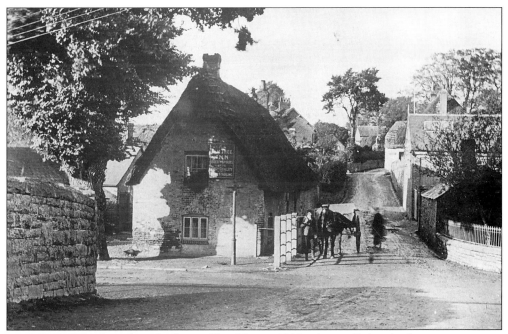

ELM TREE INN, by railway bridge at Chiseldon, c.1901, when still thatched.

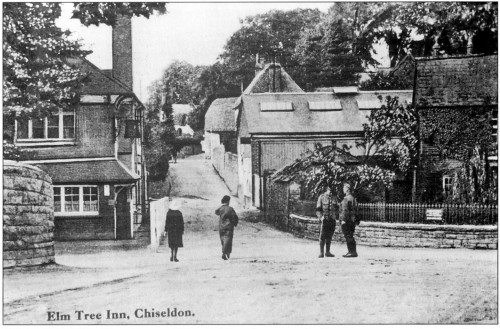

Elm Tree Inn, Chiseldon.

ELM TREE INN, Chiseldon, c.1916. Soldiers from nearby Draycott camp make friends with local girls during World War I. Many were the pints of beer handed through the station railings to troops waiting to go to France.

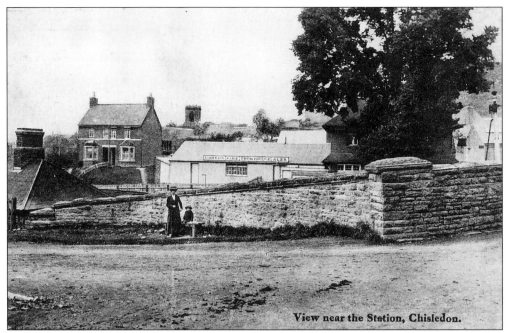

VIEW NORTH-EAST FROM RAILWAY BRIDGE, Chiseldon, c.1910, with Elm Tree Inn to right.

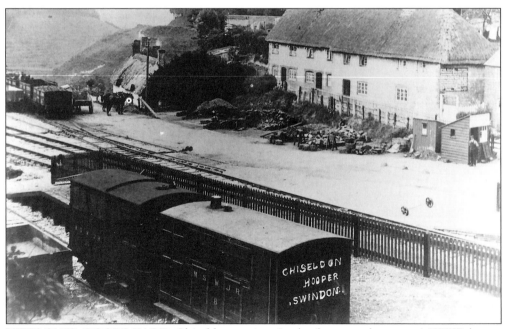

VIEW OVER GOODS YARD, Chiseldon station. In the foreground are two MSWJR horse-boxes, Nos. 8 and 10. A view taken by the well-known Swindon photographer, William Hooper, and published on a postcard in 1905.

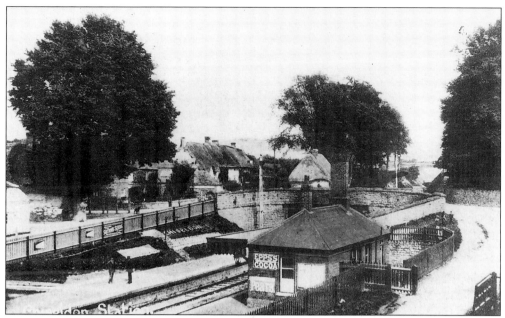

CHISELDON STATION, c.1905.
Note advertisements for Epps's cocoa
and Pear's soap on station building.
The thatched roof of the station-
master's cottage can be seen over
railway bridge. Some years later a spark
from a passing locomotive set it on
fire, and it was refurbished and re-
roofed with slates. A nursing home
now stands on this site in Station
Road.

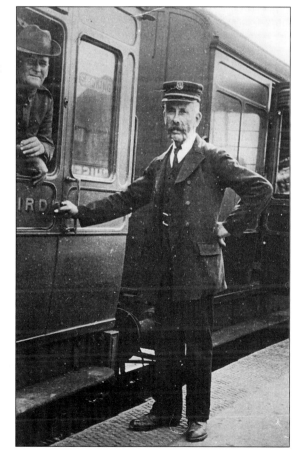

JOHN DAVIS, STATION-MASTER
at Chiseldon, 1916. Perhaps the
Australian soldier shown was going off
to fight at the Somme? Mr. Davis was
station-master at Chiseldon from 1903
to 1928.

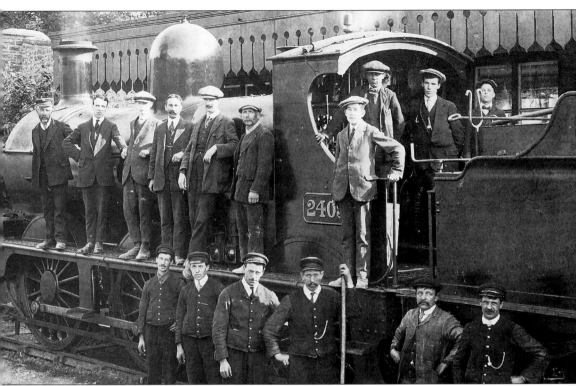

GWR 'DEAN GOODS' 0-6-0 No. 2409 at Chiseldon in 1915 on a Draycott camp working. GWR locomotives worked regularly on the MSWJR from the autumn of 1914. Staff shown (on engine left to right): John Davis (station-master), Percy Liddington, Harold Husslebee (goods clerks), Arthur Ling (from Clearing House), Fred Manning (goods clerk), 'strapper' from yard, Bert Davis (junior clerk), unidentified fireman, Percy Davis (booking clerk), unidentified 'strapper'. On ground (left to right): Fred Brown, Tom Boyles (porters), Bill Watts (foreman shunter), Bill Smith (shunter), Worthy Humphries (engineman/driver), Jack Bowden (signalman). Not on duty when the photograph was taken were Wilfred Jerome, G. Potter (junior clerks) and Jack Jerome (signalman). During World War I many 'foreign' locomotives were to be seen on the MSWJR. Two of the men shown in the photograph, Percy Davis and Tom Boyles, later joined the Army and were killed in France.

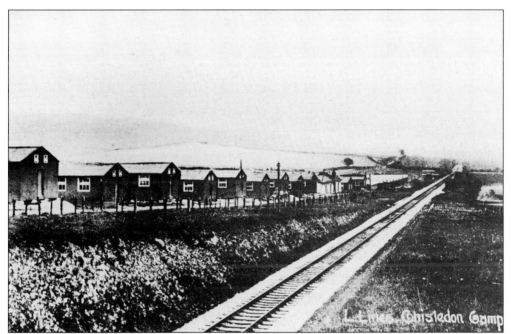

L LINES, CHISELDON (DRAYCOTT) CAMP, c.1916. In 1914 the War Office acquired a large area of downland at Draycott, near Chiseldon, and built a large training camp. A two-mile siding into the camp was opened by early 1915 from south of the station (and pulled up in 1921).

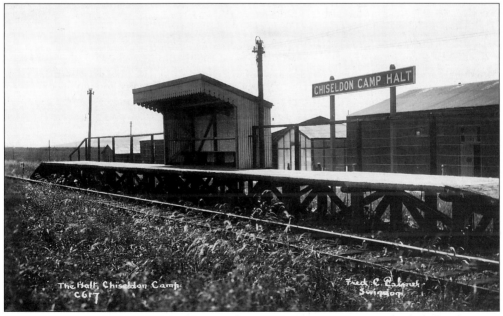

CHISELDON CAMP HALT, looking south, c.1931. The GWR opened a halt for the army camp here in December 1930, and also another at Collingbourne Kingston in 1932. (See p.115.)

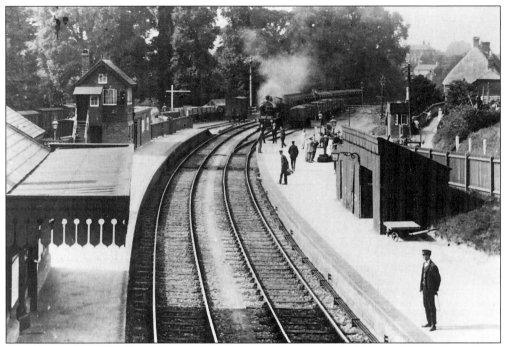

CHISELDON STATION, looking north from railway bridge, c.1920.

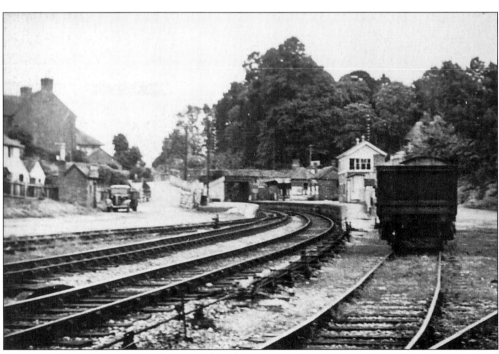

CHISELDON STATION, looking south, July 1954.

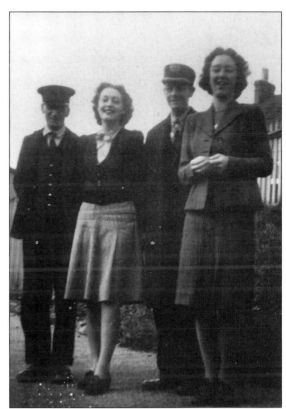

CHISELDON STATION AND STAFF, 1946. Left to right: Fred Brown (shunter), Peggy Webb (clerk), George Webb (station-master), Enid Gardiner (clerk). George Webb was to become the last station-master at Swindon Town from 1953 to 1961.

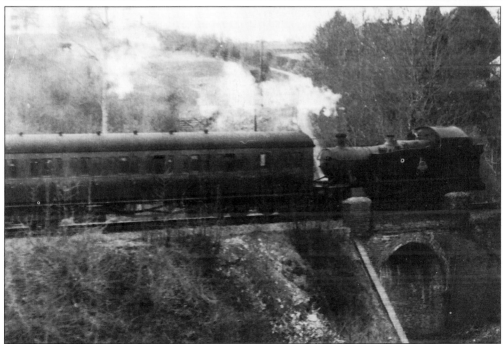

Ex-GWR 2-6-2 TANK ENGINE on southbound train on Cuckoo Bridge, north of Chiseldon station, c.1960.

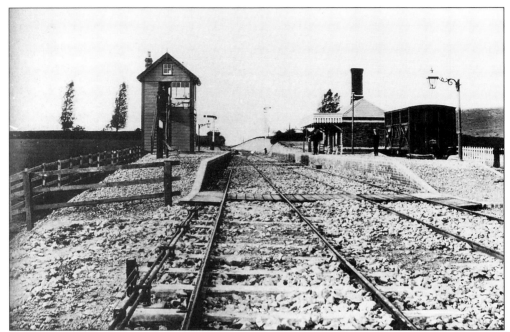

OGBOURNE STATION, looking north, July 1881. Note the cattle wagon in the siding, built by the Metropolitan Railway Carriage & Wagon Co.

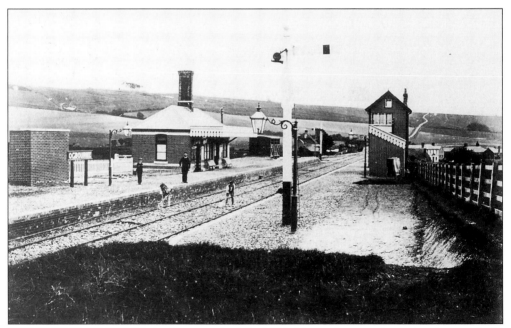

OGBOURNE STATION, looking south, July 1881. Note the ornate station lamps, single spectacle signals, and brick-built gentlemen's toilet on platform to left. The Roman road to Mildenhall is in the background.

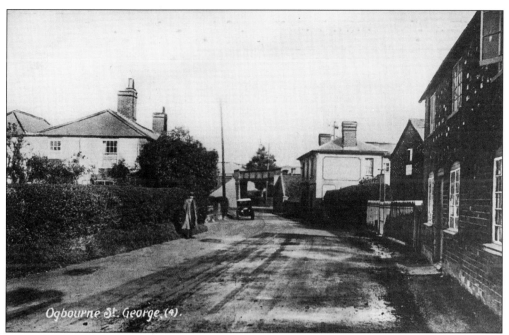

OGBOURNE ST. GEORGE, view north-east to railway bridge, in the 1920s. The bridge was demolished and the road realigned in 1964/65 after closure of the line.

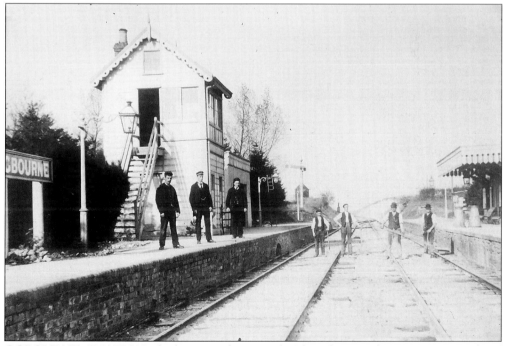

OGBOURNE STATION, looking north, c.1895. The photographer was F.H. Ault of Aldbourne.

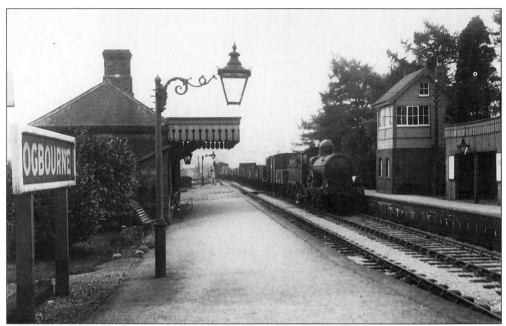

OGBOURNE STATION, looking 'down', c.1935, with GWR 4-4-0 'Duke' class locomotive on a goods train.

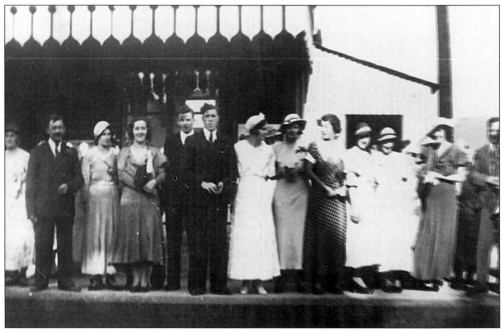

WEDDING PARTY ON OGBOURNE STATION, c.1933. The bride and groom left on their honeymoon to the sound of detonators which had been placed on the rails exploding!

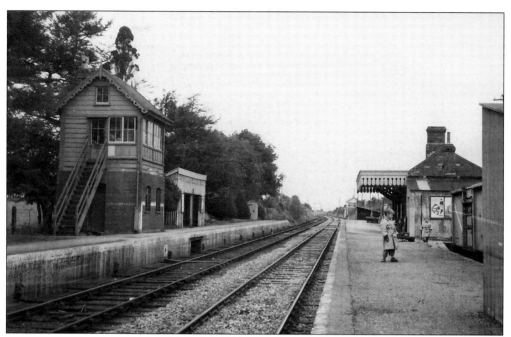

OGBOURNE STATION, looking north, September 1954. Today the Chiseldon to Marlborough railway footpath can be followed along the route of the old line.

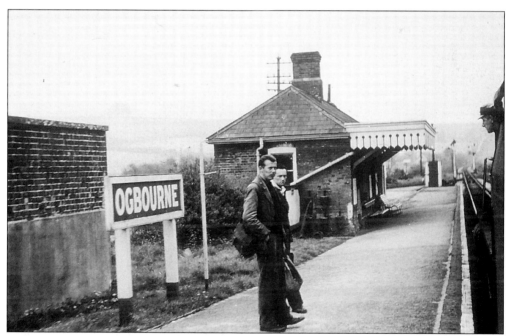

OGBOURNE STATION, looking 'down' from carriage window of train in station, c.1960. Station site was at Ogbourne St. George, to the west of the main Swindon to Marlborough road, opposite where Swindon Golf Club is today.

PRIVATE SIDING for Ogbourne St. Andrew racing stables, 1899. Racehorse traffic from Ogbourne and Marlborough stables provided a welcome source of income for the MSWJR. Entrance to the siding was opposite the lane to Ogbourne Maizey.

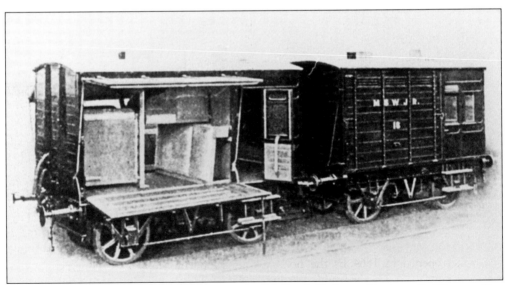

MSWJR HORSE BOXES. A manufacturer's (Midland Railway Carriage & Wagon Co., Shrewsbury) illustration of horse-box No. 18, and another as built in 1897. The racehorses were extremely well protected during their journey; there were three stalls. The grooms' compartment was lit by an oil lamp.

Seven
Marlborough
and South Wiltshire

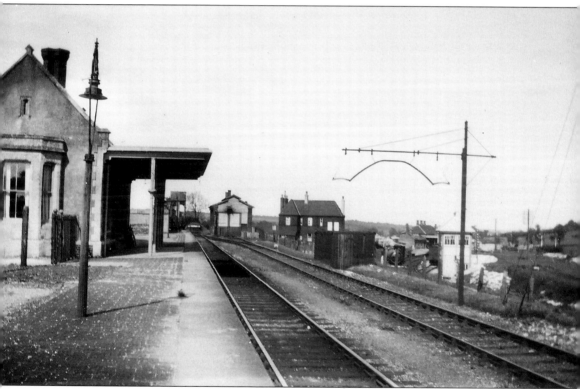

THE FIRST RAILWAY AT MARLBOROUGH was the steeply-graded branch from Savernake, opened in 1864 by the nominally independent Marlborough Railway, but in practice always worked by the GWR. The station was on a high embankment to the south-west of the town. The original plan was to run the Swindon line into this station, and then use the branch to reach Savernake, from where the new line would be continued on down to Andover. In the event, a second stage was provided, which can just be seen in the background to the right of the picture.

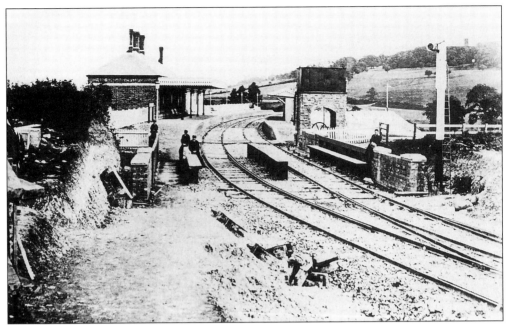

A SEPARATE LOW LEVEL STATION was finally deemed less expensive to build than a high viaduct taking the tracks into the original Marlborough station. The old and new lines were joined just to the south-west of the two Marlborough stations. The brand new station waits for passengers in 1881.

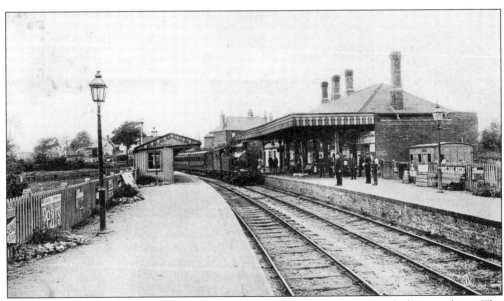

TWENTY YEARS ON, Marlborough Low Level station looks a much busier place. The buildings have hardly changed, but the MSWJR train entering the station is hauled by a modern tank locomotive, and has modern bogie carriages.

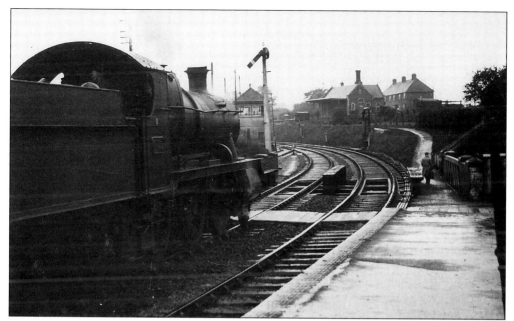

THE TWO STATIONS AT MARLBOROUGH were close together on either side of the Salisbury Road. The building with the tall chimney is the high level station, as viewed from the low level platform. Note the footpath on the right leading up to the high level station. GWR mogul No. 6322 is leaving for Savernake, en route for Southampton, just after the Second World War.

THE LINK WITH THE MARLBOROUGH BRANCH was just south of the branch terminus. The link was removed in 1898, when the MSWJR built its own lines to Grafton, but was restored in 1926 for freight transfers. In this 1931 view, the link line can be seen diverging up the hill to the right, while the main lines curve round to the left. After 1933, when the high level station had been downgraded to a freight only depôt, it became the only route into the station, with the truncated remains of the original branch being used as a headshunt

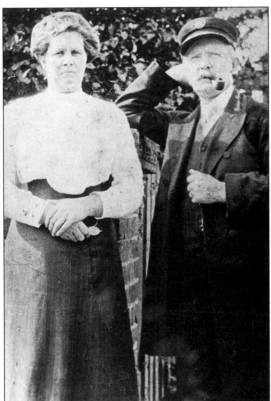

ALEXANDER BOWD, seen here with his wife, Ellen, was MSWJR station-master at Marlborough from 1899 to 1902, and from 1905 until 1926. For his last two years, he was responsible for both stations at Marlborough.

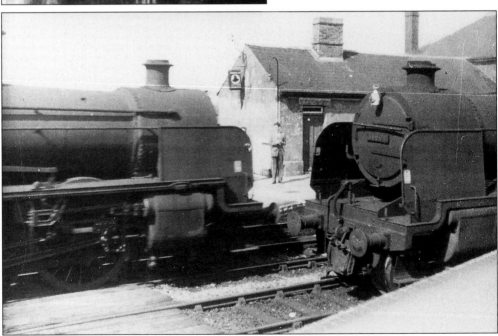

A LICENSED REFRESHMENT ROOM was provided at Marlborough station. A pair of ex-Southern Railway moguls frame the building, with its hop leaf sign for Simonds ales. It was a 'Free House', and survived for some years after the closure of the line to through traffic.

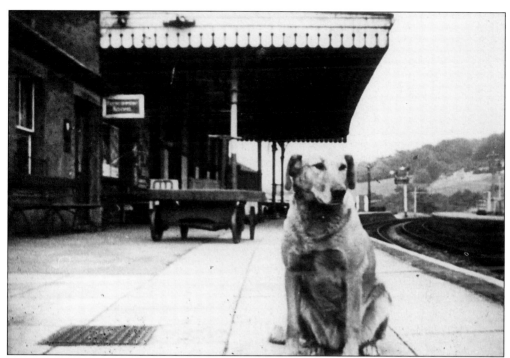

JILL WAITS PATIENTLY on
Marlborough station platform for her
master, Harold Trotman. Jill was
noted for her ability to retrieve coins
thrown into the field by the station.
When she was accused of chicken
worrying, her master won a £5 wager
by attending the court in top hat and
tails. He also won the case and
cleared Jill's name.

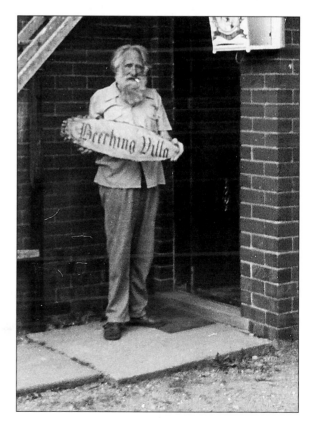

HAROLD TROTMAN was the
refreshment room proprietor after the
Second World War. A larger-than-
life character, he is holding the
nameboard of his home at Savernake,
which he had renamed 'Beeching
Villa' after the chairman of British
Railways. Harold held him
responsible for the closure of the
MSWJR line in 1961, although the
blame really lay with previous
managers, whose timetable changes
of 1958 had driven passengers away.

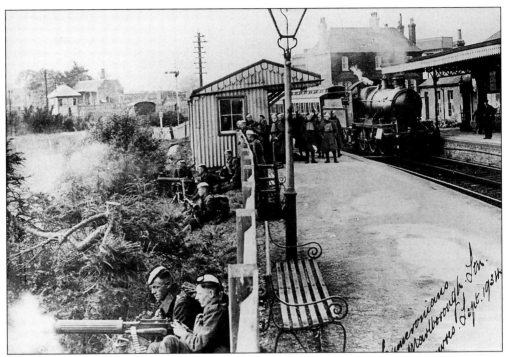

PEACE WAS SHATTERED one morning in September 1934, by the 2nd Cameronians defending Marlborough station against a mock attack, as part of their annual manoeuvres. The passengers on the morning train must have wondered what on earth was going on!

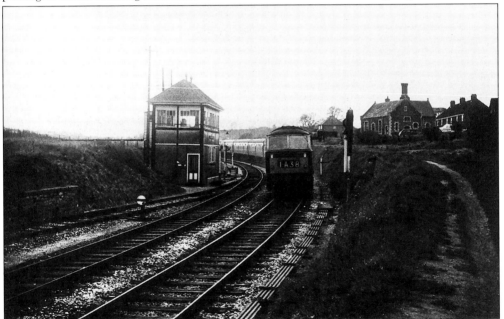

THE COLLEGE AT MARLBOROUGH had its own special trains. This is the last, in May 1964, although regular passenger services had ceased in 1961. Shortly after this photograph was taken, the Hymek diesel ran off the end of the track. Its driver had not realised that the line to Ogbourne had been lifted.

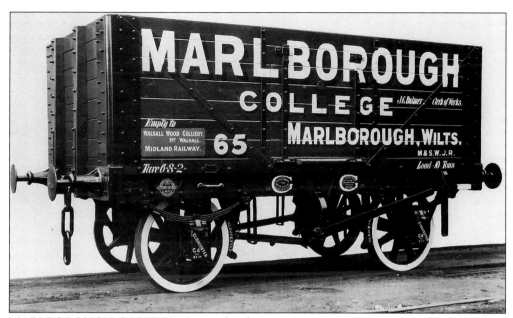

MARLBOROUGH COLLEGE also used to have its own wagons, to carry coal supplies from the collieries to the MSWJR station. Painted in purple-brown livery, with white lettering shaded in black, the college seems to have owned just three wagons. Nevertheless, for some unknown reason, they were numbered 63, 64 and 65.

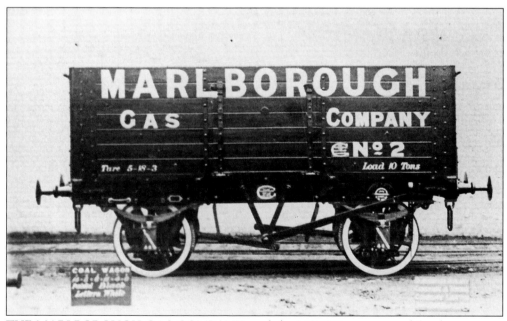

THE MARLBOROUGH GAS COMPANY used the MSWJR to carry coal for the town gas works. Their wagons were plain black, and fleet numbers started logically at No. 1. All such private traders wagons were requisitioned when the Second World War broke out.

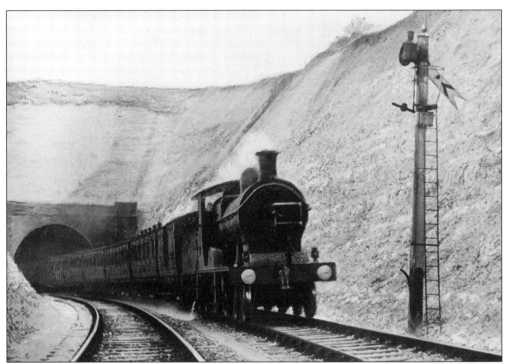

MARLBOROUGH TUNNEL was opened in 1898 as part of the Marlborough & Grafton Railway, which was built to eliminate the MSWJR's dependence on the original Marlborough branch. The new line had to be promoted as a separate company, because the MSWJR was still in chancery. MSWJR 4-4-0 No. 7 leaves the tunnel in 1913 with a North Express.

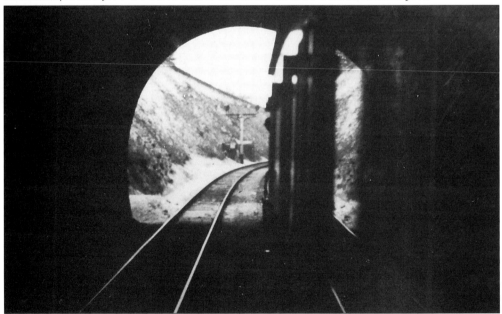

THE DAYLIGHT FADES as a southbound train enters the darkness of Marlborough Tunnel. By tunneling through the hill instead of climbing over it, the Marlborough & Grafton Railway avoided the steep gradients of the old Marlborough branch.

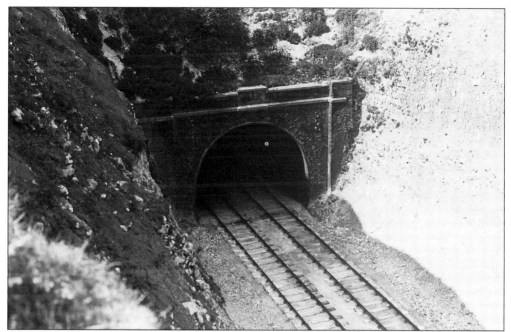

THE KEYSTONE over the southern entrance to Marlborough Tunnel bore the inscription 'M&GRly 1898'. The M&GR by-passed both the steeply graded Marlborough branch and the GWR-controlled Savernake Junction. Sam Fay described the M&GR as the keystone of the MSWJR's liberty.

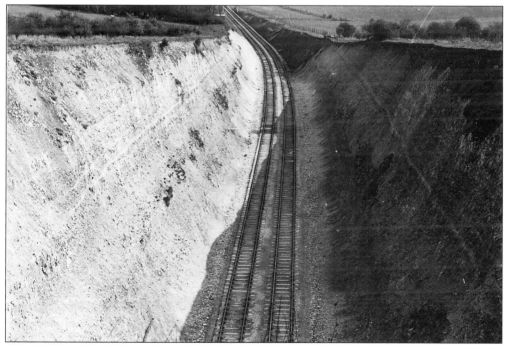

THE APPROACHES TO MARLBOROUGH TUNNEL were through steeply sided cuttings. These weathered badly, and several serious landslips occurred in the early years. As long as the line was in use, clearing up fallen chalk from the trackside was a regular chore.

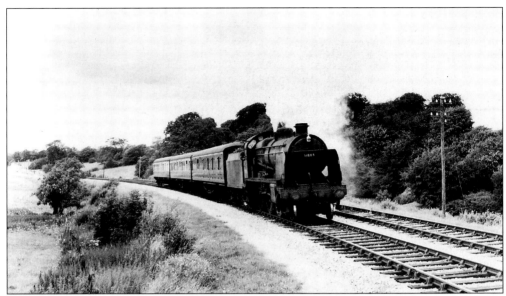

APPARENTLY ON THE WRONG LINE, ex-Southern Railway 2-6-0 No. 31803 and her train head for Southampton along the Marlborough & Grafton Railway route south of Marlborough Tunnel on 16 July 1960. After 1933, the double track M&GR became two parallel single lines. While the old 'down' road still went through Savernake High Level, the 'up' road was diverted to Savernake Low Level. After 1958, all trains used the low level route.

HAT GATE was the point where the line was diverted in 1933. Until then, the Marlborough & Grafton Railway and the old Marlborough Railway had run side by side here, but there had been no connection. The M&GR 'down' line is on the left of the picture. The 1933 link runs diagonally across the foreground from the old M&GR 'up' road to meet up with the old single line curving down to Savernake Junction. Behind the photographer, the rest of the Marlborough Railway line has been lifted.

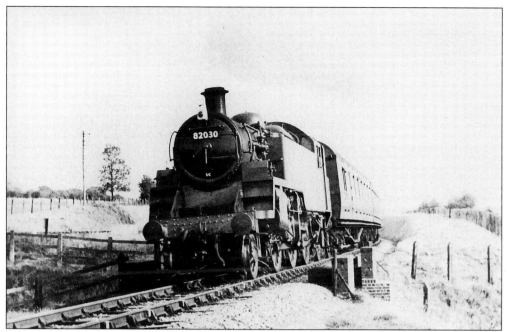

THE OLD MARLBOROUGH RAILWAY ROUTE was still used between Savernake Junction and Hat Gate after the 1933 rationalisation. In British Railways days, 2-6-2T No. 82030 climbs away from Savenake Junction. The line from Savernake High Level is in the left background.

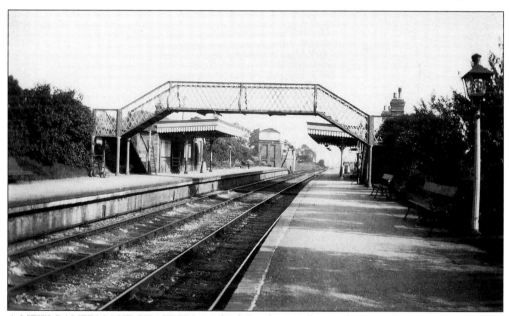

A NEW SAVERNAKE STATION was built by the Marlborough & Grafton Railway in 1898. The Marquess of Ailesbury had his own waiting room on the 'down' platform. In 1923, the station was renamed Savernake High Level. In later years, after the M&GR had been reduced to a single track, passenger trains only used the 'down' platform, and the loop was often used to park idle freight stock. All passenger traffic was diverted back to the nearby low level station in 1958.

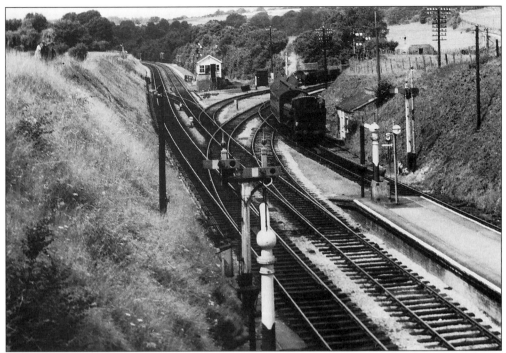

SAVERNAKE JUNCTION was where the Marlborough Railway, coming in from the right, met the GWR. The Swindon company's trains used the Marlborough line, and the GWR Berks & Hants line through Savernake station, and then regained their own metals to continue down to Andover at a point just to the east. In this 1960 view, an ex-GWR pannier tank has just brought her train down from Marlborough.

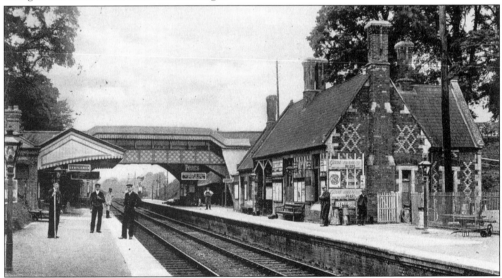

SAVERNAKE GWR STATION, on the Berks & Hants Extension line, proved a major headache. Firstly, through traffic was delayed for a year because the Board of Trade demanded improvements. Then the GWR proved difficult hosts, delaying trains and arguing about fares. With a 1 in 60 climb out of the junction restricting the weight of trains, the MSWJR soon began planning its own line past the bottleneck.

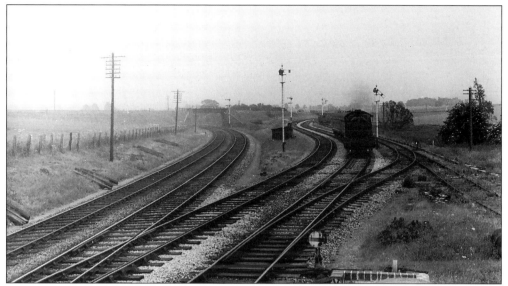

WOLFHALL JUNCTION, in the mid 1950s, with a train from Andover approaching along the original SMAR route. The tracks curving away to the left are the GWR Berks & Hants line to Newbury and Reading. It is crossed in the distance by the overbridge carrying the Marlborough & Grafton Railway. After it has joined the main line, the train will call at Savernake Low Level station, and then take the junction for Marlborough. At this time, about half the MSWJR line trains went this way, with the others taking the M&GR line across the bridge and through Savernake High Level. The M&GR was closed in September 1958, and from then on all traffic had to use the low level route.

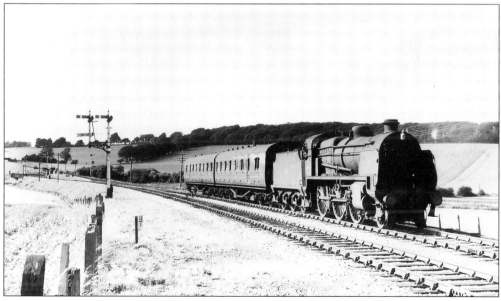

THE TWO ROUTES through Savernake met up again at Grafton South Junction. The bracket signal controls the junction between the original SMAR line down to Savernake Junction on the left and the Marlborough & Grafton line through Savernake High Level on the right. Ex-Southern Railway 2-6-0 No. 31629 is drawing away with the 4.52 p.m. train from Swindon to Andover on 18 July 1959. By this date, all trains were being routed via Savernake Junction.

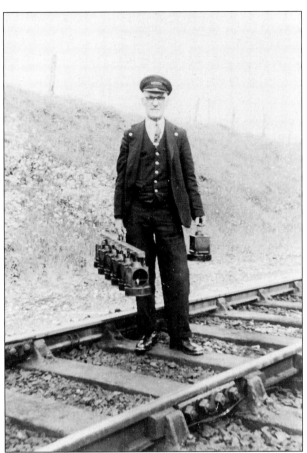

NEW LAMPS FOR OLD. GWR lampman Jim Tilley carries a load of signal lamps at Grafton Junction. The oil lamps used with the semaphore signals needed daily cleaning, refilling and trimming, and they had to be collected and taken down to the station lamp room for this work.

GRAFTON SOUTH JUNCTION had a third connection, which provided a direct route to the east over the Berks & Hants line. Seen curving away on the right of the picture, the line was often used for military traffic, but never had a regular passenger service. Ex-SR 2-6-0 No. 31801 passes the junction on 18 July 1959 with the 1.48 p.m. train from Cheltenham to Southampton.

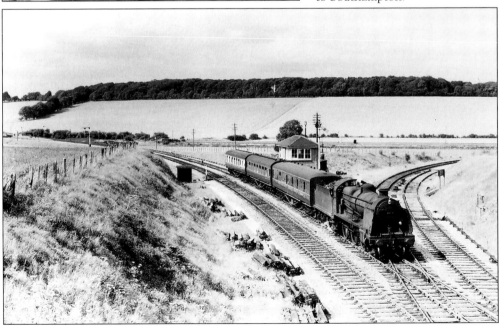

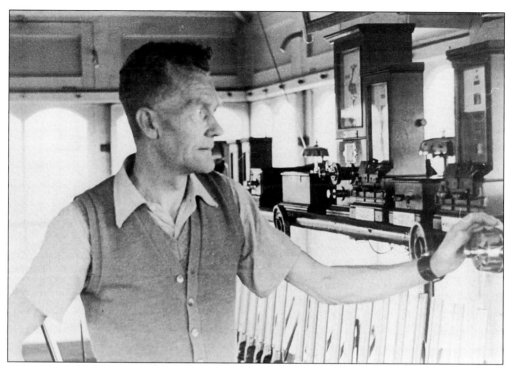

BERT PLANK, GWR signalman at
Grafton South Junction signal cabin,
with a varied selection of block
telegraph instruments. The two
mushroom shaped objects are bells.
Messages were passed between adjacent
signal cabins using codes of rings and
pauses. Different sizes of bell were used
for signalling from the next 'up' cabin
and the next 'down' cabin, so that the
source of the message could be identified
by the particular bell tone.

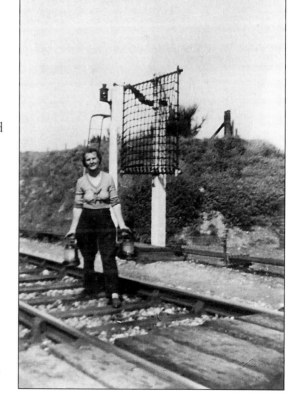

SIGNALWOMAN LIL BALL also
worked Grafton South Junction signal
cabin during World War II. The net in
the background was next to the cabin,
and was used for collecting the token,
which had given the engine driver
authority to proceed over the single line
from Savernake.

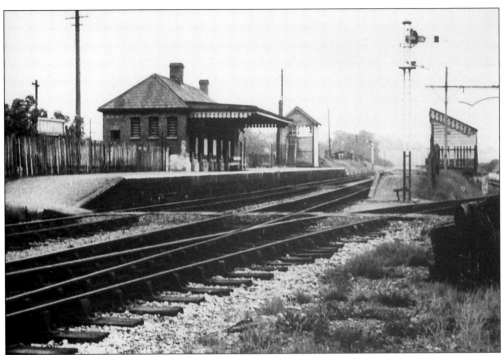

GRAFTON STATION opened in 1882 as a temporary terminus while improvements were made to Savernake Junction. It gained further distinction in 1902 when it gained its own privately-owned branch line. From then until 1909, A.J. Keeble's brickworks at nearby Dodsdown produced the bricks for building Tidworth barracks. For the rest of the time, it was a quiet wayside station.

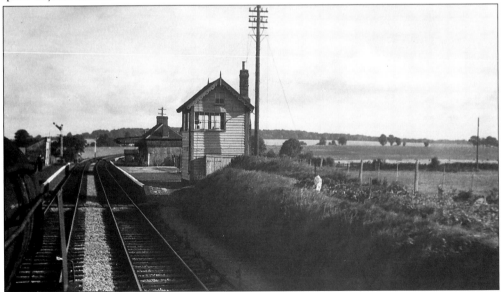

THE RURAL SETTING of Grafton station is evident in this view, taken from the footplate of an ex-Southern Railway mogul locomotive. The location was chosen such that the station could serve the nearby village of Burbage as well as East and West Grafton, from which it took its name.

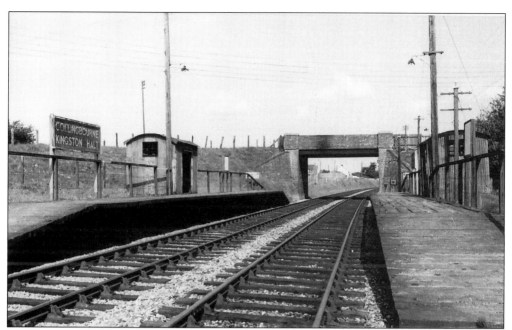

COLLINGBOURNE KINGSTON never had its own station in MSWJR days, as Victorian passengers were expected to walk the mile down the road to Collingbourne Ducis. With the growth of bus services, the travelling public became less tolerant of such inconvenience. The GWR therefore opened a halt at Collingbourne Kingston in 1932. Tickets were obtainable from a nearby house.

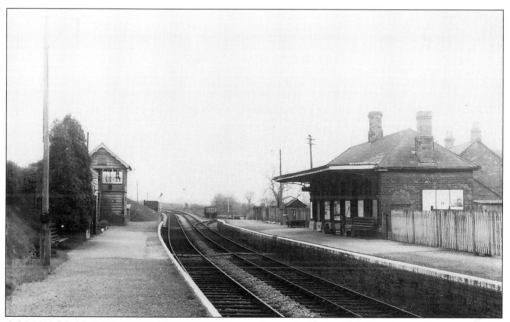

COLLINGBOURNE MSWJR STATION was located on the hillside above the picturesque village of Collingbourne Kingston. Its main traffic came from the adjacent Messrs Rawlings' agricultural machinery works, and nearby racing stables.

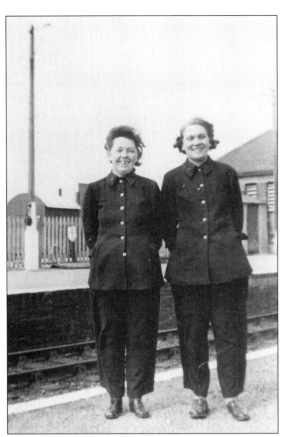

DOREEN SPACKMAN AND THELMA HOARE joined the Collingbourne station staff during the Second World War, when many of the railwaymen had gone into the armed forces.

COLLINGBOURNE, like many other MSWJR stations, handled a considerable amount of milk traffic. The raised sections of the station platforms nearest the camera were provided to facilitate the loading of the milk churns into the trains. The MSWJR ran regular milk trains down to Andover, where they were handed over to the LSWR to be taken on up to London.

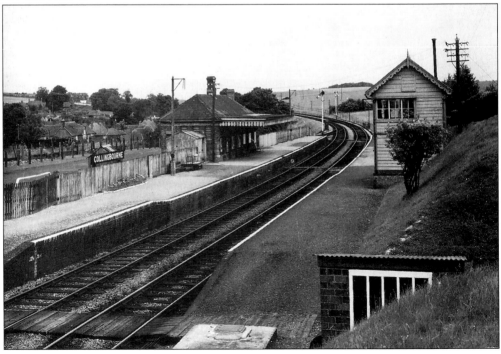

Eight

The Army

TIDWORTH BARRACKS, Salisbury Plain, c.1910. In 1897, the War Office purchased 40,000 acres of land on Salisbury Plain for training purposes. The decision to build permanent barracks at Tidworth was made in April 1899. Originally all eight barracks were to house infantry, with six barracks of artillery, and the contract was placed with Henry Lovatt in late 1901. Later on, in 1906, it became clear that Tidworth barracks would never be more than half full of infantry, and some units were converted for use by the cavalry and horse artillery. This photograph shows Tidworth station at centre left with the line to Ludgershall to the right. In the background can be seen Lucknow barracks to the centre left and Mooltan barracks to the right, with military sidings curving towards them. Construction of the link from Ludgershall commenced in 1900 and it was open for War Department traffic by May 1902. Public passengers services commenced on 1 July 1902 to Tidworth station.

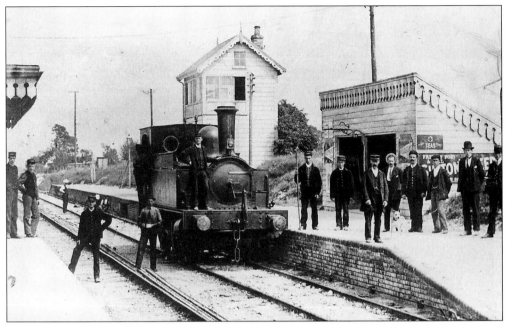

LUDGERSHALL STATION, just prior to enlargement in July 1901, with station staff and an original SMAR 0-6-0 tank engine. At centre of group to right is Frederick J. Lashbrook, station-master at Ludgershall from 1899 to 1902.

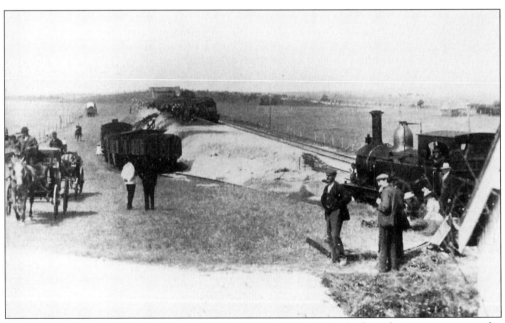

ARRIVAL OF TROOP TRAIN AT LUDGERSHALL, 1898. Before the extensions to the station platforms at Ludgershall, troops had to be detrained north of the station. Some 30,000 troops were dispatched from here in 3 days during September 1898. Note MSWJR 2-4-0 tank engine No. 8 to right.

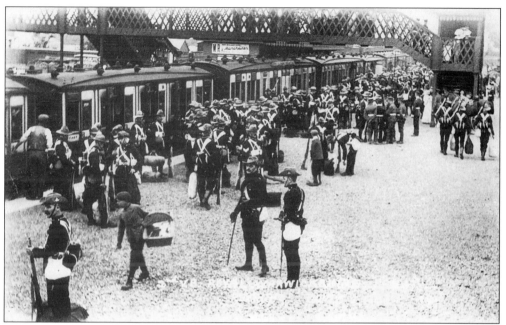

SECOND VOLUNTEER BATTALION, Royal Warwickshire Regiment, Ludgershall station, August 1906. At this period troops still wore the slouch hats from the Boer War era.

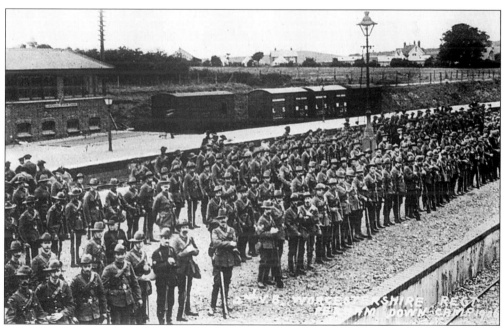

MEN OF THE 2nd VOLUNTEER BATTALION, The Worcestershire Regiment, lined up on Ludgershall station, waiting to go to their Perham Down camp, 1906.

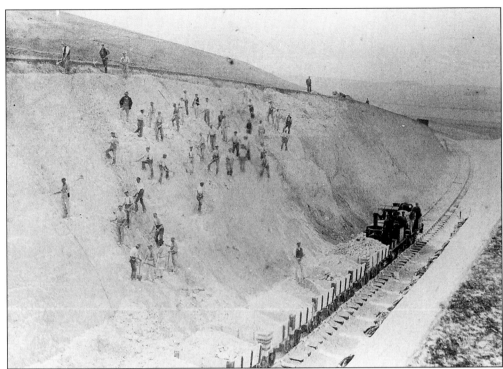

CUTTING THROUGH TIDWORTH DOWN, c.1901. A special train was run over the branch on 17 May 1901 for the benefit of Lord Roberts, army commander in chief. It was restricted to 5 m.p.h. on account of the unfinished state of the works.

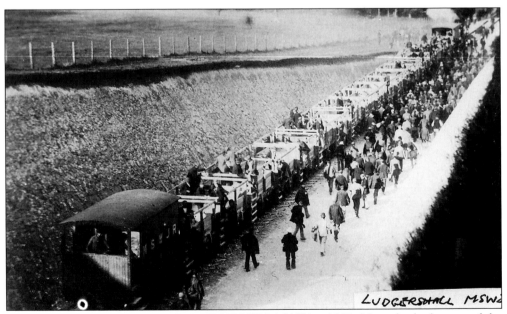

WORKMEN ALIGHTING FROM 'TIN TOWN MAIL', c.1903. Note the brake van of the MSWJR. The service was hauled by one of the contractor's own 0-6-0 saddle tank locomotives. See p.121.

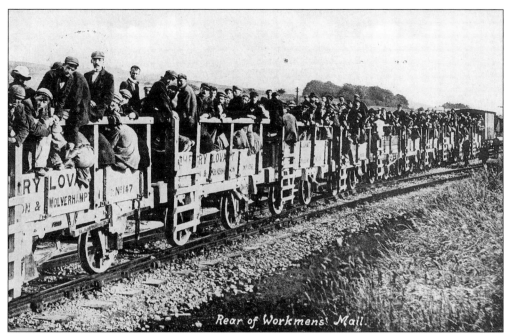

REAR OF WORKMEN'S TRAIN, carrying labourers from their temporary village at Brimstone Bottom, near Ludgershall, to construct barracks at Tidworth, c.1903. It was known locally as the 'Tin Town Mail'. Henry Lovatt, the main contractor for the building of the barracks, was also a director of the MSWJR.

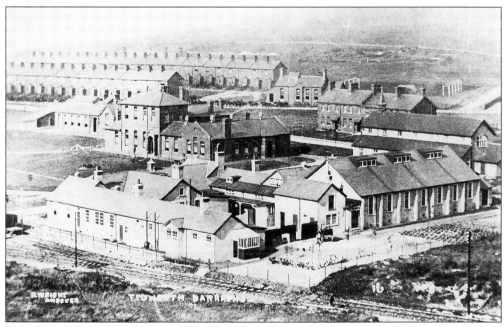

TIDWORTH BARRACKS, c.1910, with military line in the foreground.

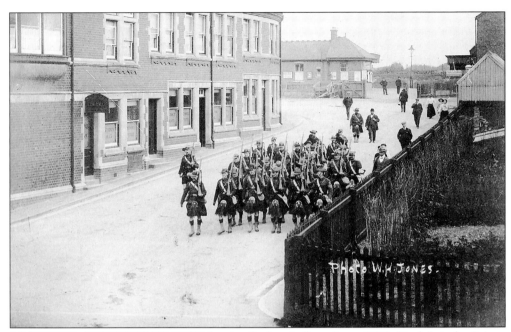

LIVERPOOL SCOTTISH TROOPS leaving Ludgershall station c.1907. On left is the Prince of Wales Hotel, facing on to the Andover Road.

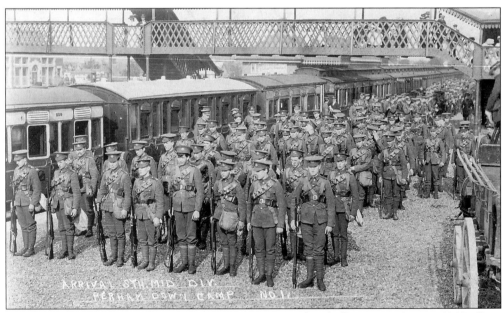

ARRIVAL OF SOUTH MIDLAND DIVISION at Ludgershall station, August 1910. Over 10,000 territorial army troops arrived from Warwickshire, Worcestershire and Gloucestershire in thirty special trains for their annual manoeuvres on Salisbury Plain.

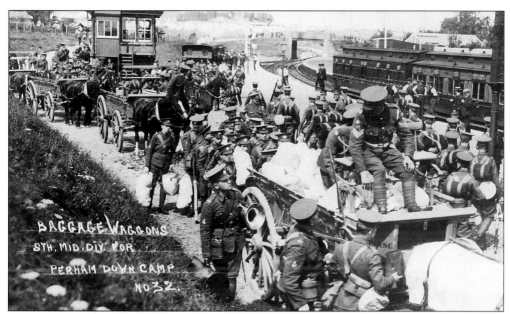

BAGGAGE WAGONS, South
Midland Division, Ludgershall station,
August 1910. Another of at least
thirty-two views taken by Fleetwood
photographer H.E. Howorth, for the
volunteer troops to send home during
summer manoeuvres on Salisbury
Plain.

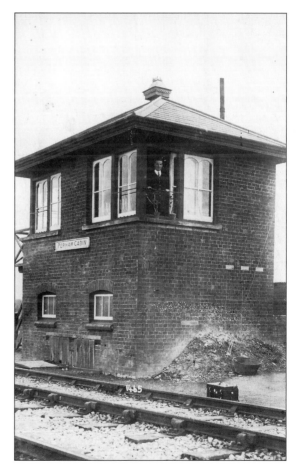

PERHAM SIGNAL CABIN, c.1910,
commissioned with the opening of the
Tidworth Military line in 1902.
Perham is near to, and west of
Ludgershall.

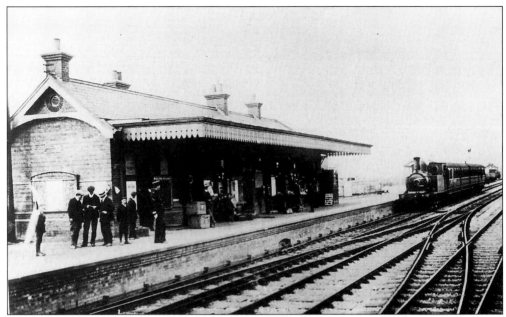

TIDWORTH STATION, c.1913, with 0-6-0 tank No. 13 on branch train. The branch had such a large volume of traffic that Tidworth station had annual receipts exceeding the total of all the other stations put together!

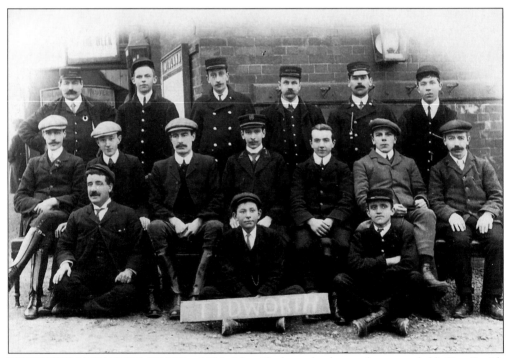

TIDWORTH STATION STAFF c.1912. Identified are, back row (extreme left), Reg Smith (signalman), and, at centre of middle row, Ernest F. Godwin, station-master at Tidworth from 1908 to 1928. Later station-master at Stapleton Road, Bristol, he retired in 1947.

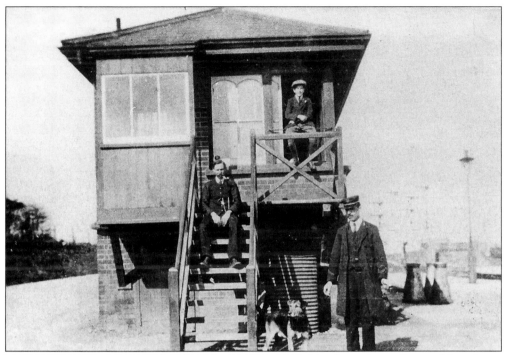

LUDGERSHALL STATION SIGNAL CABIN, 1917. To the right is George Humphries, station-master.

KING GEORGE V on horseback outside Ludgershall station, 1915. The King visited military installations on Salisbury Plain from 30 June 1915 to 2 July 1915.

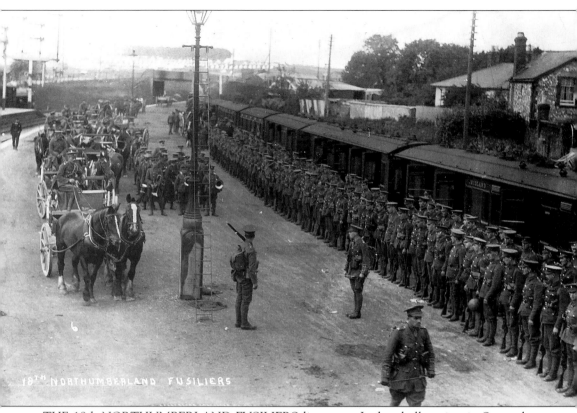

THE 18th NORTHUMBERLAND FUSILIERS line up at Ludgershall station in September 1915. Many of the soldiers are of short stature. In its search for more recruits, the army relaxed its minimum height requirements from 5ft 3in down to 5ft 1in, enabling thousands more men to join up, particularly from the north of England. They were known as the 'bantams' on account of their small size. In the left background a GWR saddle tank engine is standing in the Tidworth bay platform. The war greatly increased traffic over the MSWJR, and locomotives had to be borrowed from the GWR, LSWR, and Midland Railway to cope with all the extra trains. Many soldiers from the Salisbury Plain camps travelled to Swindon on the MSWJR on Saturday evenings. This resulted in GWR men giving the line the nickname 'Piss 'n' Vinegar', from the smell in MSWJR carriages after these outings!

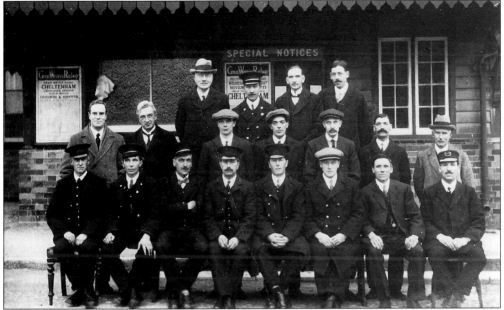

LUDGERSHALL & TIDWORTH FIRST AIDERS, 1924. Back row (left to right): H.R. Griffiths (Divisional Superintendent), Harry Randle (shunter), Ernest Godwin (station-master, Tidworth), Mr. Carpenter (haulier). Centre row: -?-, -?-, -?-, -?-, Bert Lock (signalman), Frank Maryfield, Sam Rumbold. Front row: Clayton Cowley, Harry Skeplorn, Dick Mortimer, Jim Barlow (signalmen), -?-, Reg Smith (signalman), Vincent (driver), George Humphries (station-master, Ludgershall).

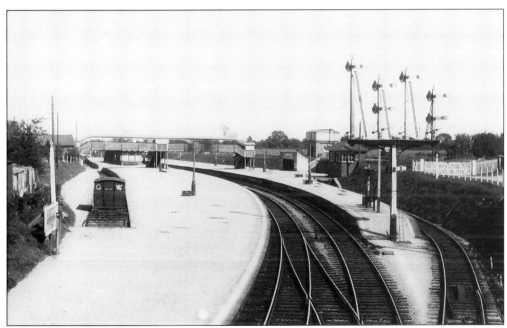

LUDGERSHALL STATION, looking 'down', 1932. The largest station on the MSWJR, with platform space of 16 acres.

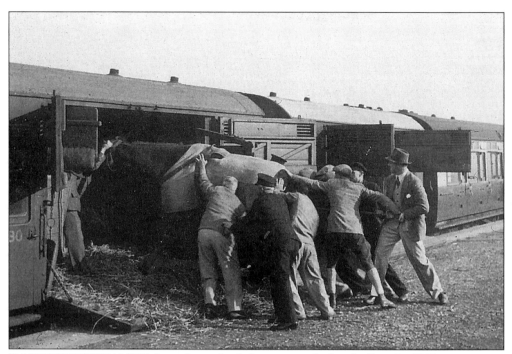

'PASSIVE RESISTANCE'; horse being loaded to train at Ludgershall in the 1930s.

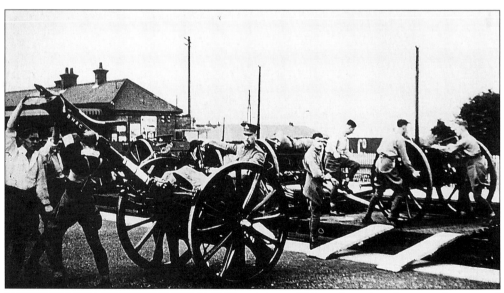

HONOURABLE ARTILLERY COMPANY arriving at Tidworth station, for annual camp and manoeuvres, September 1937.

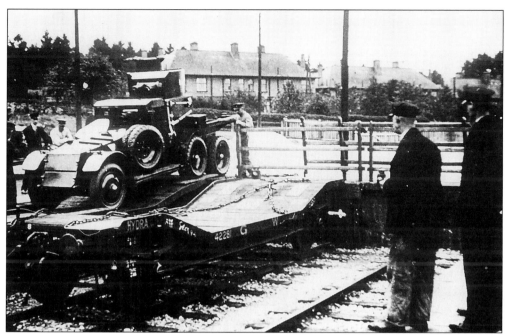

ARMOURED CARS awaiting unloading at Tidworth station, 1939.

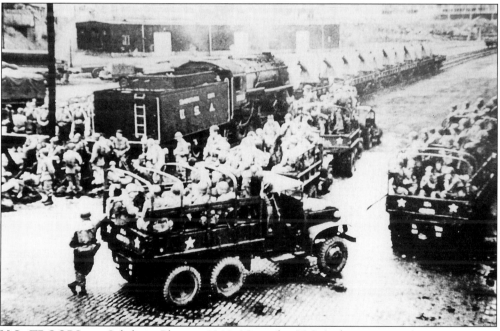

U.S. TROOPS on Salisbury Plain, c.1944. Note the U.S.A. locomotive. American troops occupied the Tidworth garrison from July 1942 to April 1946. After the end of World War II many of the G.I. brides were housed in the barracks waiting shipment to the U.S.A. to join their husbands.

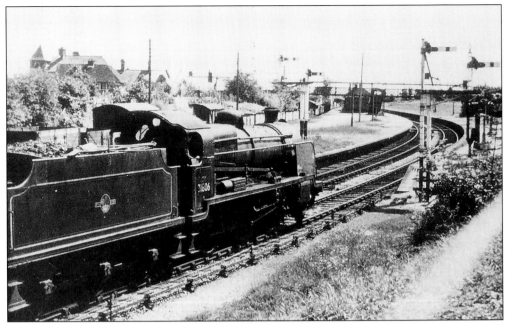

LUDGERSHALL STATION, May 1961. Ex-Southern Railway 'U' class 2-6-0 No. 31806 entering station from north.

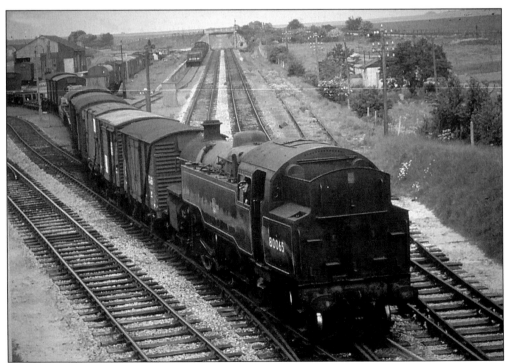

BR STANDARD 2-6-4 TANK No. 80065 shunts the yard at Ludgershall, June 1965. The old MSWJR route north can be seen truncated at the road bridge in the distance.

Nine
Into Hampshire

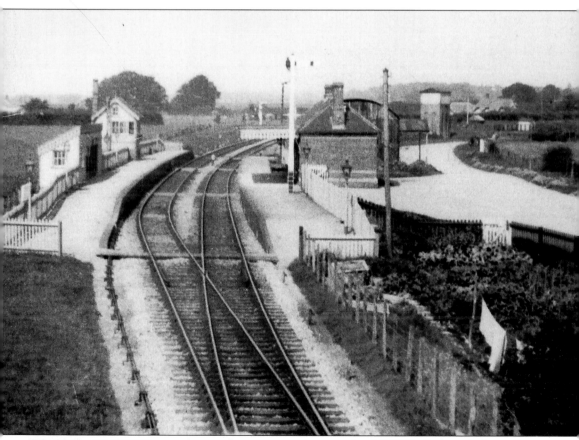

WEYHILL STATION was the southernmost station on the MSWJR line, and the only MSWJR station entirely in Hampshire. Like several others, it was some distance from the village it was intended to serve.

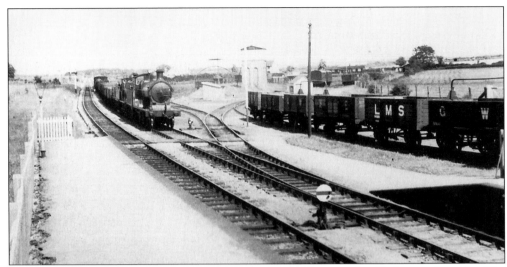

WEYHILL SHEEP FAIR was held every October, providing considerable livestock traffic. The sidings to the right of the tall water tower were provided for loading and unloading of cattle and sheep. An ex-MSWJR 4-4-0 is passing with a 'down' freight train, c.1932.

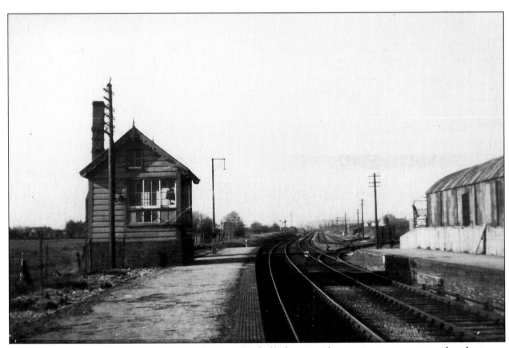

THE TWO LONG GOODS SIDINGS at Weyhill that can be seen running into the distance to the right of the main running lines were the scene of a notorious accident. One dark night in October 1891, a guard got caught between two wagons during shunting. There was uproar when it transpired that both he and the engine driver had been at work for over 22 hours when the accident occurred, and that such hours were by no means unusual.

THE GWR STAFF AT WEYHILL in
1932 were, left to right, station-master
Arthur Chapman, porter Leslie Blackmore,
and signalmen Reg Dance and Ernie
Parfitt. Note the name on the station
lamp, which would have been removed
during World War II because it might have
been helpful to spies!

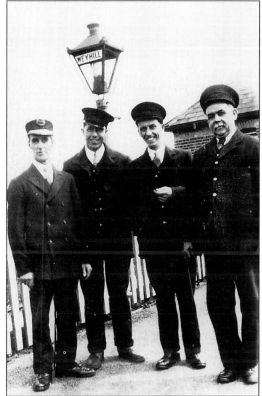

THE MSWJR PERMANENT WAY was
strengthened by the GWR, allowing
heavier locomotives to be used. As heavier
also meant larger, it was necessary to check
that the fresh types did not foul any
lineside structures. The GWR 28xx class
2-8-0 and an 'Aberdare' class 2-6-0 are
visiting Weyhill in 1932 to check platform
clearances.

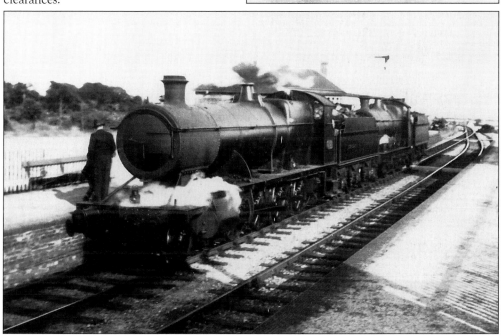

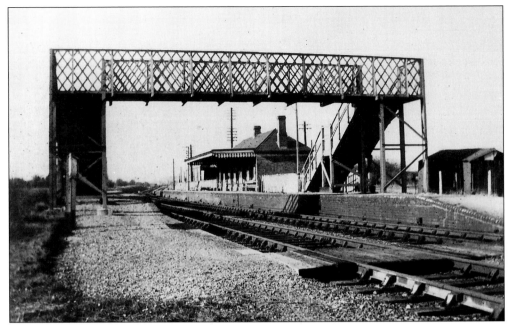

A SHORT-LIVED FEATURE at Weyhill station was its footbridge, erected in 1942 to facilitate military traffic. It was removed soon after the end of the war. The only other MSWJR stations to boast a footbridge were Swindon Town and Savernake.

WEYHILL TO RED POST JUNCTION was single track until 1943, when it was doubled. Work had just started on laying the second track when this picture was taken of the southern approach to Weyhill station.

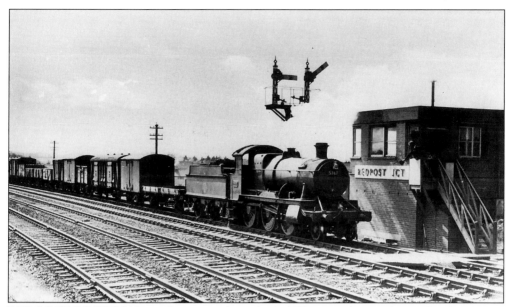

RED POST JUNCTION was the point where the MSWJR met the London & South Western Railway main line to Salisbury. MSWJR distances were measured from here, yet for most of the time it was a junction in name only, as the MSWJR trains were provided with their own separate track through to Andover. Signal cabins were put in to facilitate military traffic during both World Wars, this one dating from 1943.

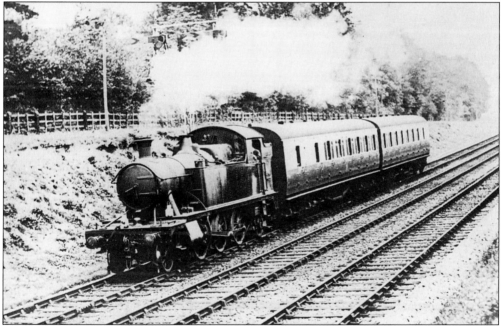

A THIRD TRACK was laid by London & South Western Railway alongside its main line, to give MSWJR trains access to Andover Junction station without interfering with main line traffic. The first few trains used the main line in 1882 until the third line was ready. The lines were then separated until January 1919, when a junction was put in for military traffic. Not needed in peacetime, it was taken out in 1936, only to be restored in 1943 for World War II.

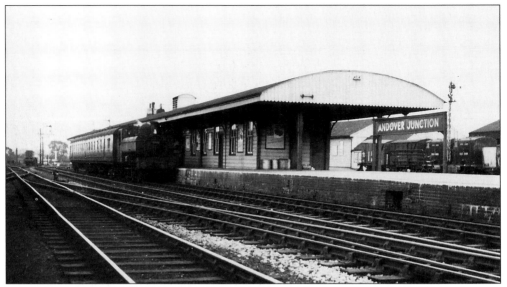

THE LSWR ANDOVER JUNCTION STATION was the terminus for MSWJR local trains, although many services continued on through to Southampton over the LSWR Andover & Redbridge line. Ex-GWR pannier tank No. 9795 stands by the outer face of the island platform on the north side of the main line, which was used exclusively for MSWJR trains. Even so, some through MSWJR services used the other side of the platform, sharing with LSWR trains on the 'up' main line.

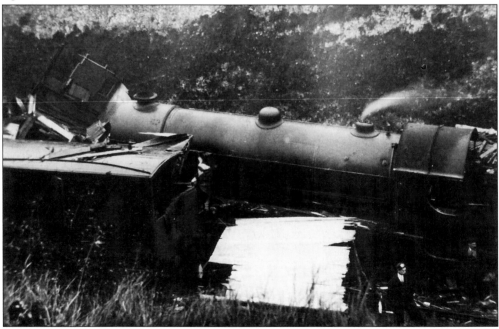

AN ACCIDENT to an LSWR freight train at Andover Junction in October 1914 damaged MSWJR goods brake van No. 17, along with several other wagons standing in the sidings. The LSWR locomotive is 'H15' class 4-6-0 No. 488. Almost two years later to the day, in October 1916, a similar accident occurred to an LSWR freight train at Andover, damaging some MSWJR milk vans.

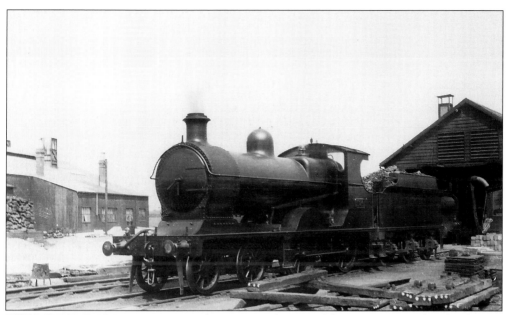

THE MSWJR ENGINE SHED at Andover was to the east of the station, immediately adjacent to the LSWR main line. Ex-MSWJR 4-4-0 No. 1126 stands outside the shed in 1928. The building to the left is the LSWR shed. When the LSWR needed to rebuild their shed in 1904, the only suitable location available was a site further away from their main line.

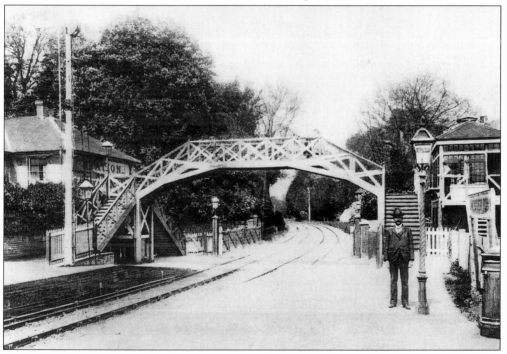

ANDOVER TOWN was the first station on the LSWR line to Southampton. The line descended from Andover Junction down an incline, part of which was as steep as 1 in 62. The level crossing behind the footbridge was the scene of several accidents due to runaways of MSWJR trains on the incline.

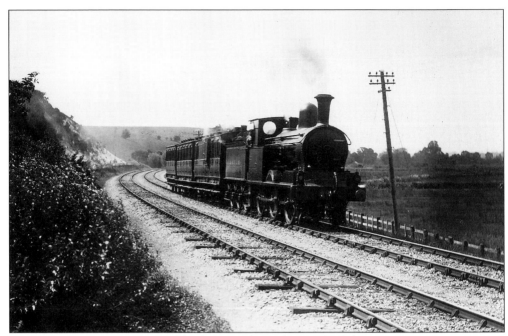

THE TEST VALLEY near Stockbridge provides a pleasant backdrop to an MSWJR passenger train in 1901. The track here generally followed the line of an earlier canal, and as such was easily graded, but had many curves.

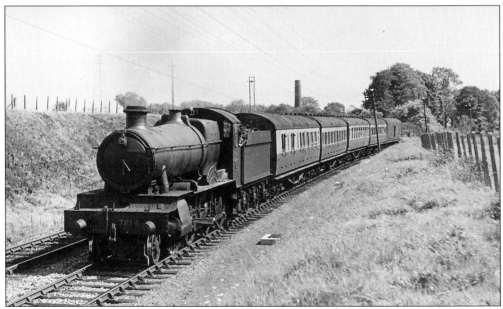

DEEP IN SOUTHERN RAILWAY TERRITORY, GWR 'Manor' class 4-6-0 No 7818 *Granville Manor* heads north from Redbridge with a Southampton to Cheltenham train, just after the Second World War.

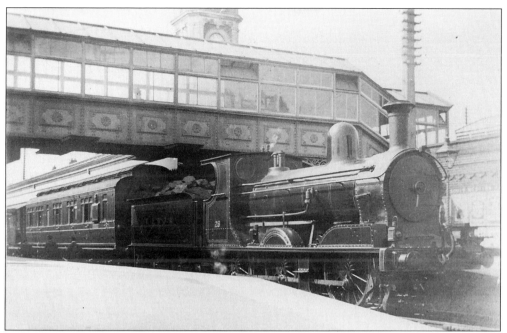

SOUTHAMPTON WEST STATION, renamed Central in 1935, is today the main station for the city, but MSWJR through passenger trains only called here on their way to the terminus by the docks. MSWJR 0-6-0 No. 28 pauses with a 'down' passenger train in the summer of 1901. The leading carriage belongs to the Midland Railway, and will have been worked through from Derby.

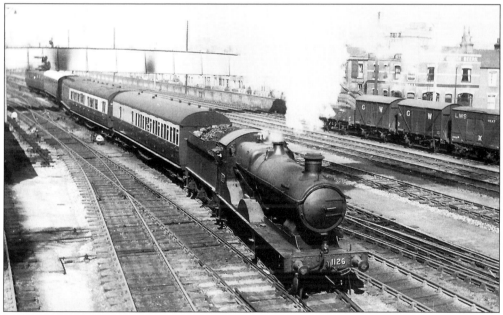

JOURNEY'S END for ex-MSWJR 4-4-0 No. 1126, old No. 8, as she enters Southampton Terminus with her train from Cheltenham. The locomotive has been fitted with a standard GWR taper boiler. The date is about 1935. No. 1126 was the last ex-MSWJR 4-4-0 in service when she was withdrawn in December 1938.

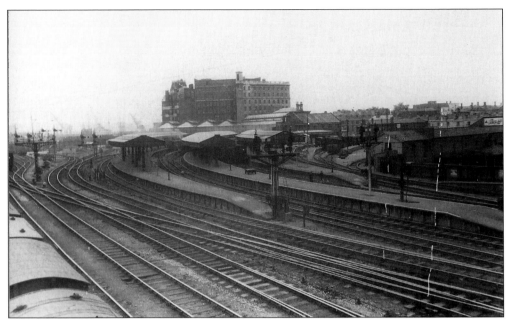

THE ULTIMATE DESTINATION for MSWJR passenger trains from the summer of 1893 was Southampton Docks station. Renamed Southampton Town & Docks in 1896, and Terminus in 1923, it was actually just across the road from the Eastern Docks complex. The tall building in the background is the South Western Hotel. It is just possible to make out dock cranes to the left of the building.

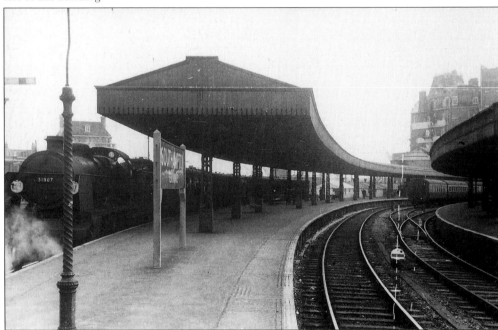

SOUTHAMPTON DOCKS STATION was designed to cope with large numbers of passengers. Excursionists would usually catch the ferries to the Isle of Wight, although the more adventurous ones would aim for the Channel Islands or France. Emigrants would transfer to the ships to take them to more distant destinations.

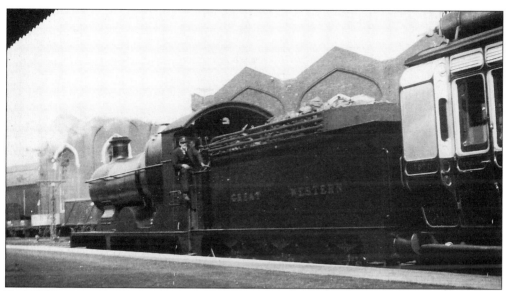

Ex-MSWJR 4-4-0 No. 1128 awaits the 'right-away' from Southampton Terminus in the mid 1920s. The provision of through carriages meant that it was possible for passengers to use the MSWJR route to travel as far north as Liverpool without changing trains. The journey took just over seven hours.

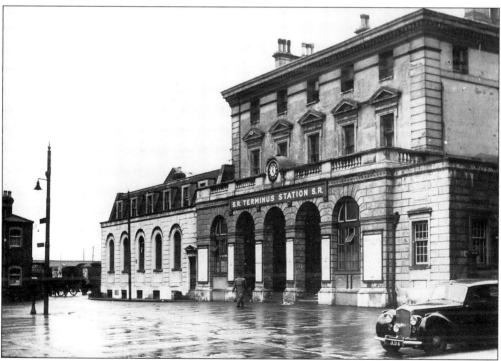

SOUTHAMPTON TERMINUS STATION, as seen from the road on a wet day in February 1950. At this date there were still horse-drawn delivery vans in the yard. The building dates from the opening of the line in 1840. The station closed to passengers in 1966, and to parcels traffic in March 1968. The building is listed, and still survives, although no longer used for railway purposes.

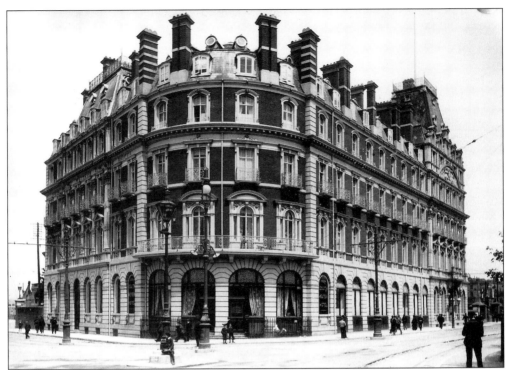

THE SOUTH WESTERN HOTEL overshadowed the station buildings at Southampton Docks station. Opened in 1865 as the Imperial Hotel, it was not an immediate success, and closed in 1868. It reopened in 1870 as the South Western Hotel, and was bought by the LSWR in 1882. From 1904 it had a time ball on the roof, which was dropped at precisely 10 a.m. every day to allow people to check their clocks and watches against Greenwich Mean Time. It was requisitioned during the Second World War, and became offices, being renamed South Western House in 1957.

THE SOUTHAMPTON DOCK COMPLEX was the final destination for MSWJR through freight trains. Exports included manufactured goods from the Midlands and North, and Burton beer, while imports included early vegetables from the Channel Islands. A large number of railway wagons are visible in front of the magnificent ocean liners.

Ten
Locos and Trains

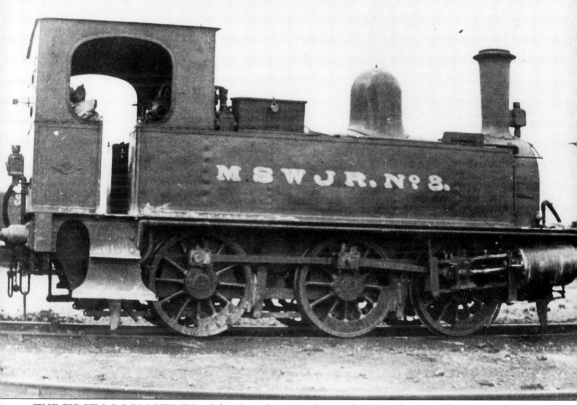

THE FIRST LOCOMOTIVES of the Swindon, Marlborough & Andover Railway were three small tank engines of the 0-6-0 wheel arrangement, built by Dübs & Co. of Glasgow in 1881. They were more suited to shunting than to cross-country services. No. 3 is seen here after refurbishment by Avonside Engine Co. in 1901. Outclassed by the later locomotives, she was sold to contractor S. Pearson & Sons in 1906. She was sent to work on a contract at Kingston-on-Hull docks, where she was given the name *Kirkella*, after a nearby village.

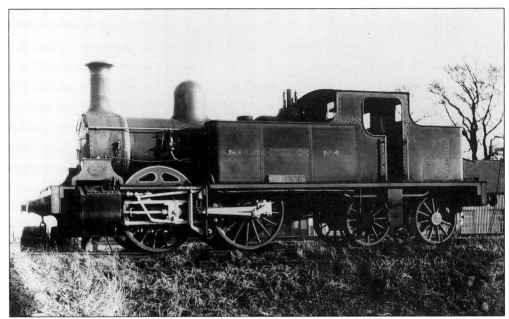

LOCOMOTIVE No. 4 was built on the Fairlie principle, with the driving wheels mounted on a bogie instead of solid main frames. She was also one of the first in Britain to use Walschaerts valve gear. Potentially fast and powerful, she proved unreliable, and was not considered worth repairing after an accident at Marlborough in 1889.

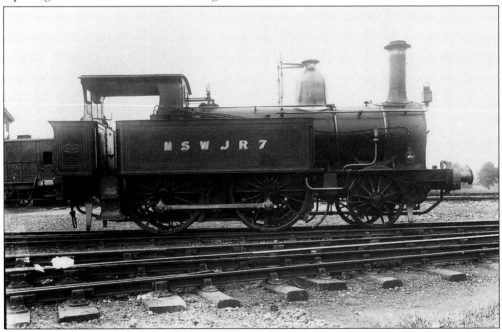

THE MAINSTAY OF EARLY SERVICES were three tank engines of the 2-4-0 wheel arrangement, numbered 5, 6 and 7, which were supplied by Beyer Peacock & Co. of Manchester in 1883. No. 7 stands in Cirencester yard in the early 1900s. Outclassed by more modern locomotives, No. 6 was sold in 1906 (see p.154), and the other two were withdrawn for scrap a few years later.

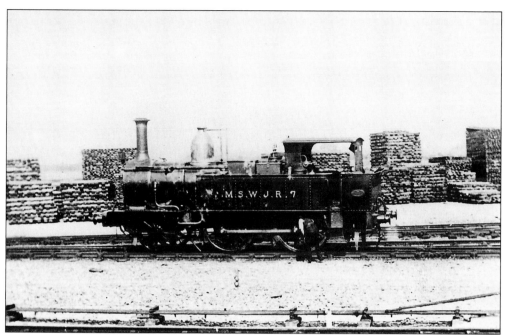

BEYER PEACOCK 2-4-0 TANK No. 7 stands in front of piles of permanent way materials in Cirencester Works yard around the turn of the century. The MSWJR had to put a lot of work into strengthening its original lightly laid road to take express trains, using money loaned by the Midland Railway. Some of the old rails were sold to the Wantage tramway.

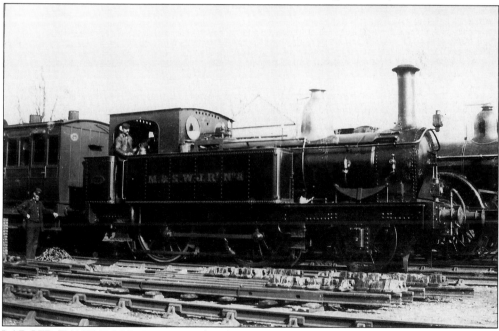

LARGER TANK ENGINES were ordered in 1884. Three were built, numbered 8, 9 and 10, but manufacturers Beyer Peacock wisely waited for payment for No. 8 before delivering the other two. As the SMAR could not find the money, the others went instead to the East & West Junction Railway, later known as the Stratford on Avon & Midland Junction.

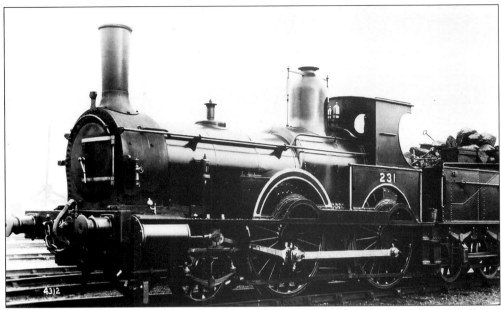

LONDON & SOUTH WESTERN RAILWAY LOCOMOTIVES were borrowed to make up for the shortage of engines. LSWR 2-4-0 No. 231 was on loan from Whitsuntide in 1889 until January 1890, and again from March 1891 until May 1893. She had been built by Beyer Peacock in 1866, to the order of LSWR locomotive engineer Joseph Beattie. By the time she came to the MSWJR, she had been extensively modified by William Adams.

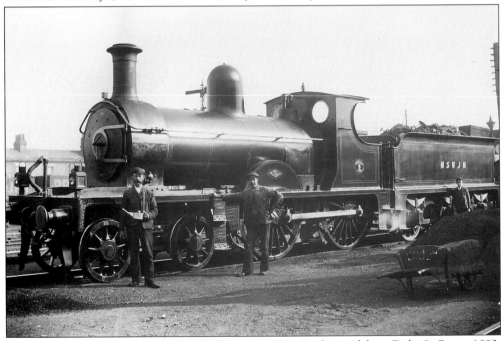

THE FIRST MSWJR TENDER ENGINE was 4-4-0 No. 9, obtained from Dübs & Co. in 1893, thanks to a personal loan from MSWJR director Percy Mortimer. The company desperately needed locomotives of this calibre to work through services between Cheltenham and Southampton. No. 9 lasted until the GWR takeover, but was then withdrawn.

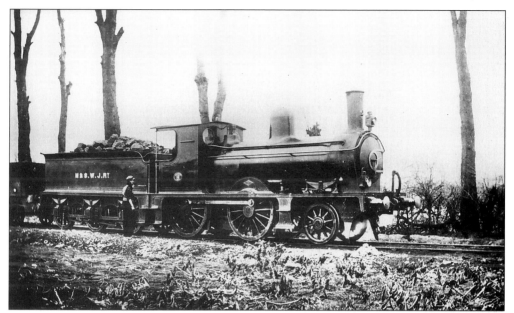

A TRUST FUND was set up in 1894 to buy new engines and rolling stock. No. 10 was one of a trio of 2-4-0 tender engines, obtained with sisters 11 and 12 from Dübs & Co. of Glasgow. They were an excellent buy, giving almost sixty years of service.

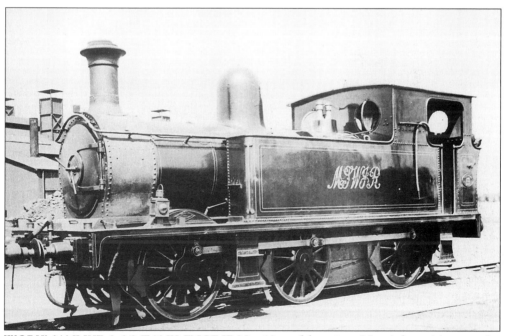

WORKMANLIKE 0-6-0 TANK ENGINE No. 13, and her sister No. 4, later 14, were also obtained from Dübs in 1894. They were used on both freight and local passenger trains. After 1901, one of the pair was stationed at Andover for use on the Tidworth branch. Although mechanically they had much in common with the 2-4-0s, they had much shorter lives, being withdrawn soon after the GWR takeover.

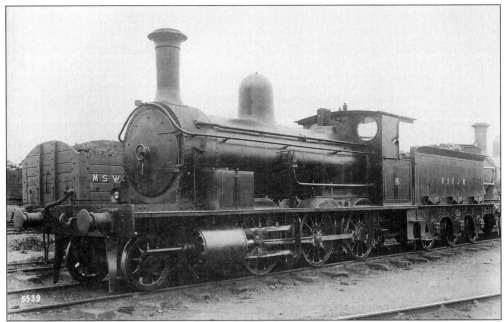

THE NEW SOUTH WALES GOVERNMENT RAILWAYS of Australia ordered some powerful 2-6-0 locomotives from Beyer Peacock & Co. in 1881. A very similar locomotive was built for the MSWJR in 1894, as No. 14, followed by No. 16 in 1896. Nos. 14 and 16 were used on the heavy through freight traffic between Cheltenham and Southampton Docks, No. 16 acquiring the nickname 'Galloping Alice'.

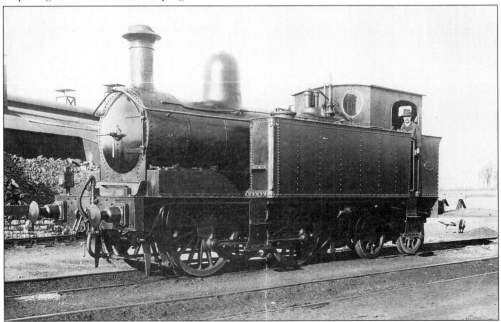

THE WIRRAL RAILWAY bought an 0-4-4 tank engine from Beyer Peacock & Co. in 1894. The MSWJR ordered this identical locomotive from the same manufacturers in 1895, as their No. 15. She is seen here at Andover Junction shed on 30 April 1921. Her main use was on local passenger services.

148

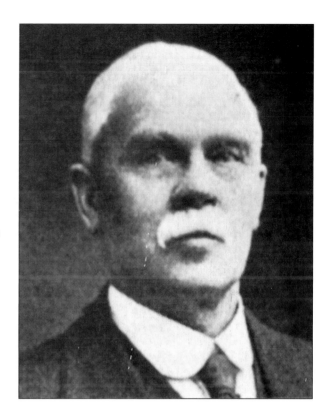

JAMES TYRRELL was head of the MSWJR locomotive department from his promotion from driver in 1892 until the GWR takeover in 1923, when he retired. He was given the official title of Locomotive and Carriage Superintendent in 1903, and was responsible for the specification which resulted in the successful class of MSWJR 4-4-0s introduced in 1905.

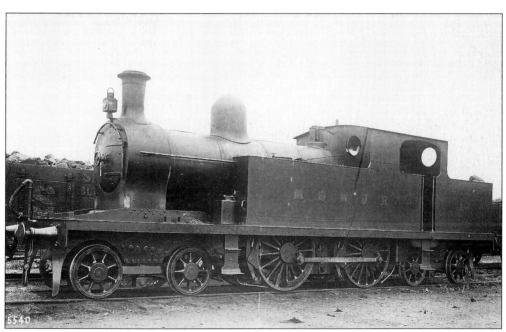

A HANDSOME MSWJR TANK ENGINE, with the unusual 4-4-4 wheel arrangement. No. 17, and sister No. 18 were built by Sharp Stewart in 1897. Intended for express passenger services, sadly their performance did not match their looks. They were poor steamers, suffered from lack of adhesion, and were prone to overheated bearings.

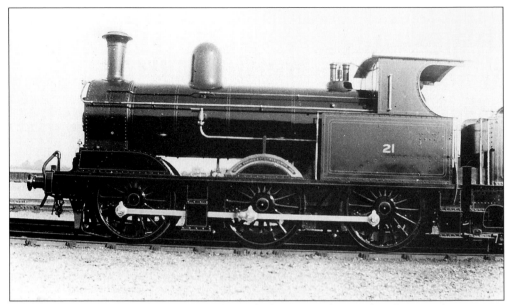

A MAID OF ALL WORK. Beyer Peacock supplied six versatile mixed traffic 0-6-0 locomotives in 1899, as MSWJR Nos. 19–24. They were used on both freight and passenger services, and were well liked by their crews, although some felt that a larger boiler would have been an advantage. The large rectangular rear splashers were later cut down to the minimum necessary to cover the rear coupled wheels.

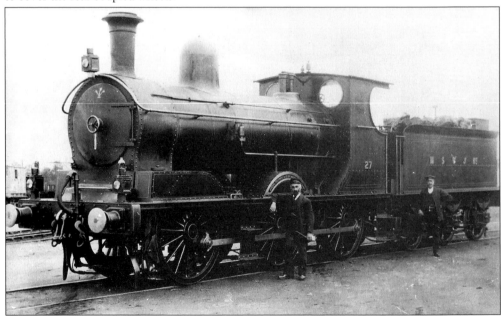

THE STANDARD CLASS of 0-6-0s was enlarged to a total of ten locomotives in 1902, when Beyer Peacock provided Nos. 25–28. Unlike the first batch, the cab sidesheets lacked the large rectangular lower panels, probably to improve access to the firebox. No. 27 waits at Cheltenham in the early 1900s. Note the emblem polished into the smokebox door with emery powder, and the three headlamps which, prior to the First World War, indicated that the locomotive was hauling an empty stock train.

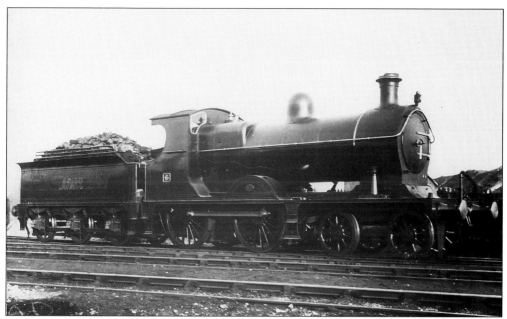

THE PRIDE OF THE LINE were the class of nine 4-4-0 tender locomotives, built by the North British Locomotive Company, Glasgow. The first of the class was introduced in 1905, followed by eight more over the next decade. No. 6, seen here at Cheltenham on 17 March 1923, was built in 1910.

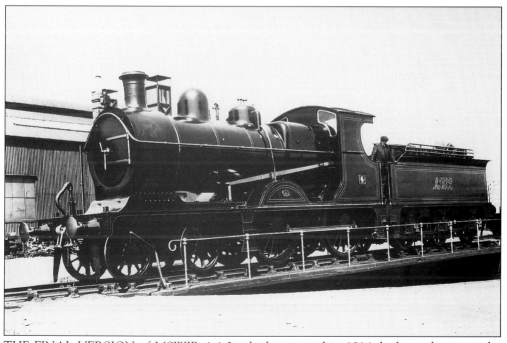

THE FINAL VERSION of MSWJR 4-4-0, which appeared in 1914, had two domes on the boiler. The forward one was the normal steam dome, the second housed the water feed and carried the safety valves. No. 4 looks very smart as she stands on the Andover turntable on 30 April 1921.

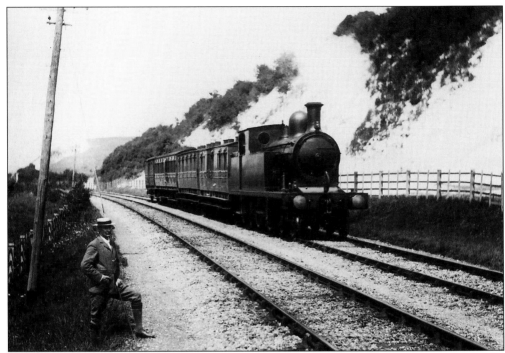

MSWJR PASSENGER TRAINS began modestly in the early 1880s, descended to the ramshackle in the early 1890s, and were transformed into respectability by the turn of the century. Locomotive No. 17 heads for Southampton in the summer of 1901 with a typical passenger train consisting of two six-wheeled carriages, a bogie coach, and a four-wheeled passenger brake van.

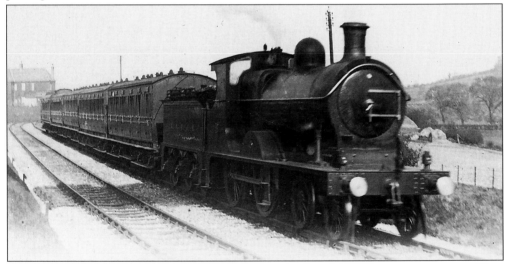

THE NORTH AND SOUTH EXPRESSES were the best MSWJR passenger trains. They usually included at least one through coach for passengers to and from Birmingham and beyond. From 1910, passengers were guaranteed a smooth ride in steam-heated bogie coaches hauled by a modern 4-4-0 locomotive. No. 8 leaves Marlborough with a South Express in August 1914. MSWJR passenger locomotives and coaches were painted crimson lake. Midland through carriages were similar, LNWR through carriages were plum and off-white.

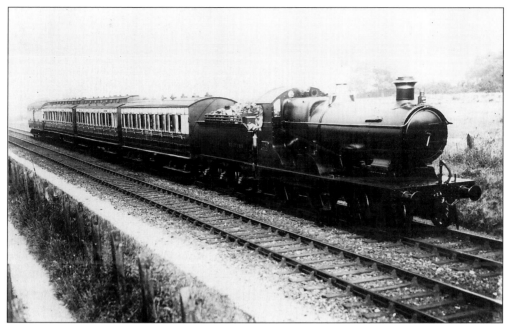

THE GREAT WESTERN INFLUENCE was soon to be seen on the trains. MSWJR crimson had entirely disappeared in October 1925, when green liveried rebuilt 4-4-0 No. 1128 headed a train of chocolate and cream coaches down towards Cheltenham. The leading coach is an ex-MSWJR vehicle; the rest of the train is made up of standard GWR stock.

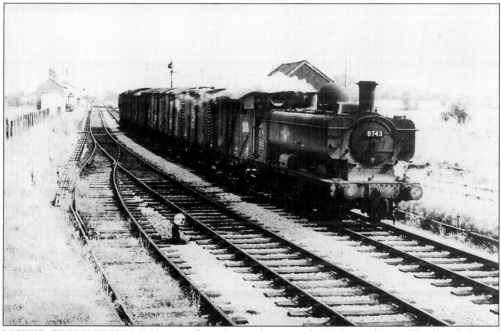

MSWJR FREIGHT TRAINS were short by modern standards, being limited by the ability of the steam locomotives to cope with the gradients. Nevertheless, ex-GWR pannier tank No. 8743 has a worthwhile load of vans as she prepares to leave Foss Cross in the 1950s with a 'down' freight. A comparable pre-grouping train appears on page 17.

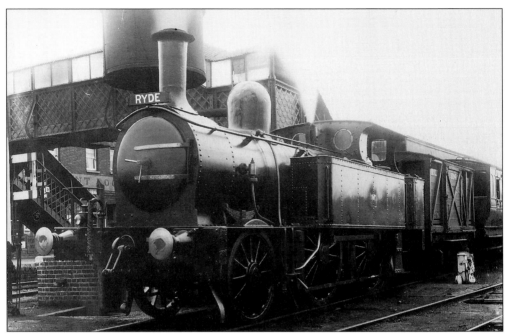

THE ISLE OF WIGHT was a popular destination for MSWJR excursionists. One of the locomotives made the same journey in 1906, when 2-4-0T No. 6 was sold to the Isle of Wight Central Railway. Now numbered 7, she carries a new chimney, has Westinghouse brakes, and carries a Ryde destination board. She became Southern Railway No. W7 in 1923, and lasted until 1928.

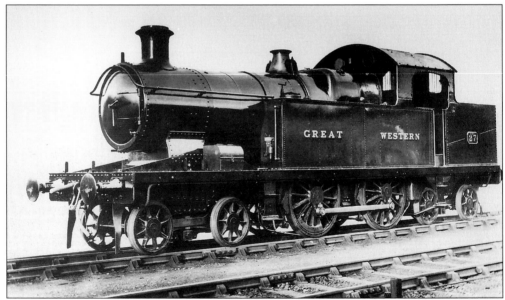

THE GREAT WESTERN RAILWAY took over the MSWJR fleet in 1923. A GWR taper boiler changed the appearance of the MSWJR locomotives completely. 4-4-4T No. 18 became GWR No. 27 when rebuilt with GWR boiler No. 6800KA. The locomotive was scrapped in 1929, but the boiler was repaired, and after service on various locomotives still survives on preserved GWR 0-6-0 pannier tank No. 9400 in Swindon Museum.

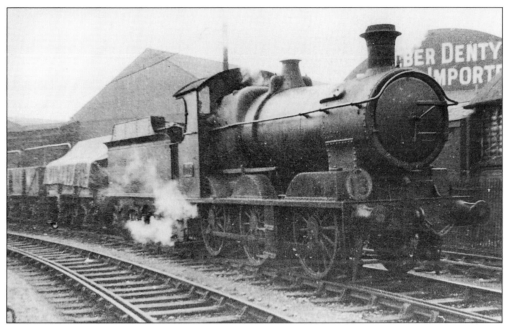

ALL THE MSWJR 0-6-0s were rebuilt with taper boilers. GWR No. 1011, old No. 27, is away from home territory as she heads a freight into Bristol docks in the early 1930s. Three members of the class were withdrawn from service in 1934, No. 1011 was withdrawn in 1937, and all had gone by the end of 1938.

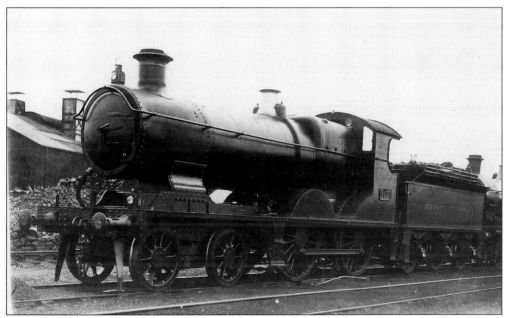

A REBUILT 4-4-0. The GWR also rebuilt six of the large 4-4-0s with taper boilers and new cabs. The first to be dealt with, in the summer of 1924, was MSWJR No. 3. Renumbered 1121, she waits at Andover shed for her next turn of duty soon after her conversion. She was withdrawn from service in 1936. Sister locomotive No. 1126, old No. 8, was the last of the class to go when she was withdrawn in December 1938.

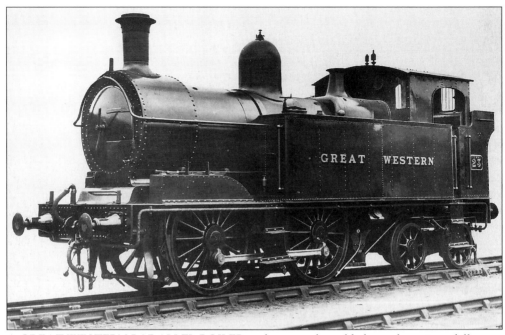

A GREAT WESTERN PARALLEL BOILER and a new cab could also make quite a difference to the appearance of an MSWJR engine. This 0-4-4 tank, No. 15, looks quite different as GWR No. 23. Between 1927 and her withdrawal in 1930, she was the regular engine on the Swindon Junction–Swindon Town shuttle, commonly known as the Old Town Bunk.

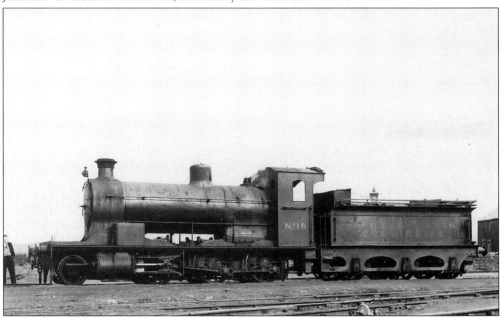

THE NORTH BRITISH RAILWAY rebuilt 2-6-0 No. 14 after she was sold to the government during World War I. After rebuilding, she worked for a time at Rosyth dockyard in Scotland. Towards the end of the war she was sold to the Cramlington Coal Company in County Durham, becoming their No. 15. When this shot was taken at Seaton Delaval in June 1934, she had become Hartley Main Colliery No. 16. She lasted until 1943.

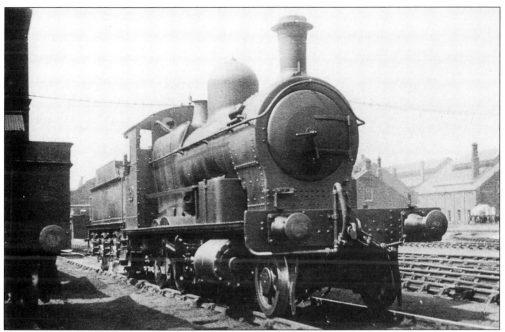

THE GWR TREATMENT of 2-6-0 No. 16 was just as drastic as that given to her sister. With a new boiler and cab, and renumbered 24, she worked the pick-up goods between Swindon and Stoke Gifford, now Bristol Parkway, until her withdrawal in 1930. In her new guise she had acquired another nickname, being known as 'Galloping Gertie'!

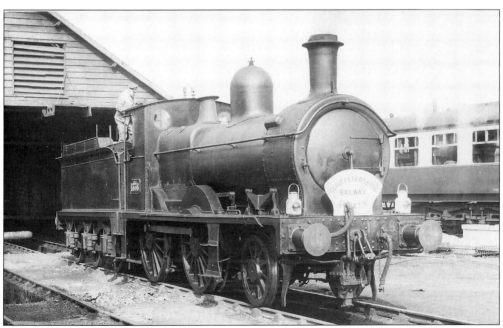

THE BEST KNOWN ex-MSWJR LOCOMOTIVES were the 2-4-0 tender engines, Nos. 1334/5/6, originally MSWJR Nos. 10, 11 and 12. After reboilering by the GWR, they all survived to become British Railways property. No. 1336 is seen at Andover after returning to the MSWJR for her swansong, hauling an enthusiasts' special over the line on 9 May 1953.

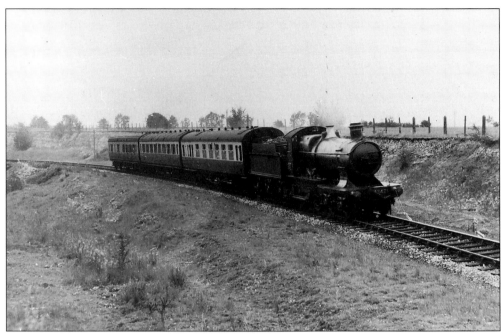

BY THE LATE NINETEEN-THIRTIES, the trains over the MSWJR route were typical of GWR cross-country services. Passenger trains usually consisted of elderly 4-4-0 locomotives hauling a modest train of just three or four carriages, like this example passing Foss Cross quarry.

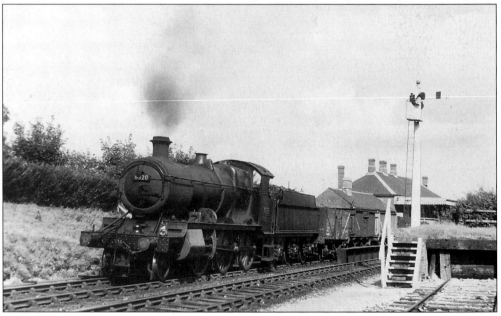

AFTER THE SECOND WORLD WAR, the GWR 43xx class 2-6-0s was the most common motive power on the line, together with 'Manor' class 4-6-0s on the best passenger trains, and pannier and small prairie tanks on lesser services. No. 6320 leaves Marlborough with a 'down' freight on 1 September 1952. In later years, the signalling was modified to allow many of the passing loops at the smaller stations to be switched out, but it is not known why this 'down' train should be running through a major station like Marlborough on the 'up' line.

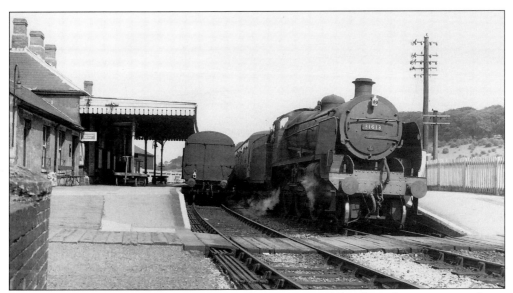

EX-SOUTHERN RAILWAY MOGULS took over many of the through passenger workings during the 1950s. 'U' class 2-6-0 No. 31613 stands at Marlborough on 4 August 1958 with the afternoon passenger train from Cheltenham to Southampton. By this date there was only one through train in each direction.

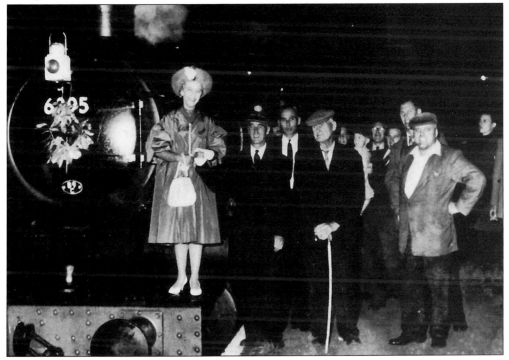

THE LAST REGULAR PASSENGER TRAINS ran between Swindon and Andover on 10 September 1961. Ex-GWR locomotive No. 6395 carried a wreath on the smokebox. The Mayor of Andover, Councillor Ms. B.P.E. Machin, was at the station to meet the train when it arrived from Swindon. See also p.81. The man in the foreground with the stick is 87-year-old Thomas Winchcombe, who travelled on the first SMAR train in July 1881.

Acknowledgements

D. Barrett, D. Bartholomew, D. Bedford, D. Bird, D. Bishop, R.K. Blencowe, G. Bond,
H. Bozzard, T. Bryan, R. Carpenter, H.C. Casserley, R.M. Casserley, P. Chapman,
L.E. Copeland, Mrs. E. Coplestone, A.W. Croughton, W.C. Curtis, H. Davies, J. Davies,
T. Flinders, C.K. Hatton, J. Hollick, H.G.W. Household, Mrs. M. Howard, R. Hoyle,
Mrs. M. Hunt, N. Irvine, R. James, Mrs. J. Jeffries, Mrs. J.E. Jones, P. Karau, B. Lait, G. Lait,
Rev. A.W. Mace , C. Maggs, B. Marchment, R. Montgomery, B. Moody, Mrs. C. Morgan,
J. Page, H.W. Payne, J. Plaister, Mrs. M. Philpin, J. Rice, T.B. Sands, J.J. Smith,
J.B. Sondermann, P. Strong, R. Tomkins, Mrs. M.E. Townsend, H.F. Trotman, A. Vaughan,
Mrs. P. Vincent, D. Viner, Mrs. J. Walker, K. Weeks, Mrs. M. Wilkie, G. Wirdnam

Andover Museum, British Rail, Corinium Museum, Cricklade Historical Society,
David & Charles (L&GRP), GWR Museum, Swindon, Ian Allan Ltd. (Real Photographs),
the *Illustrated London News*, Lens of Sutton, Loco Club of Great Britain,
Ludgershall History Society, National Railway Museum, Public Record Office,
Railway Magazine, Robert Humm & Co., Stations UK, South Cerney Trust,
Swindon Society, Wiltshire Library & Museum Service

Selected Bibliography

BARNSLEY M.P., *The Midland & South Western Junction Railway, Vol.2, Locomotives*; Wild
Swan, 1991 (*Vol.3, Rolling Stock*, in preparation)

BARTHOLOMEW D., *The Midland & South Western Junction Railway, Vol.1, Stations*; Wild
Swan, 1982

BRIDGEMAN B., with BARRETT D. & BIRD D., *A MSWJR Album*; Redbrick, 1981

BRIDGEMAN B., with BARRETT D. & BIRD D., *Swindon's Other Railway*; Alan Sutton &
Redbrick, 1990

MAGGS C.G., *The Midland & South Western Junction Railway*; David & Charles, 1967

SANDS T.B., *The Midland & South Western Junction Railway*; Oakwood Press, 1958, 1975, 1990